IMAGES
of America

UPPER NISQUALLY
VALLEY

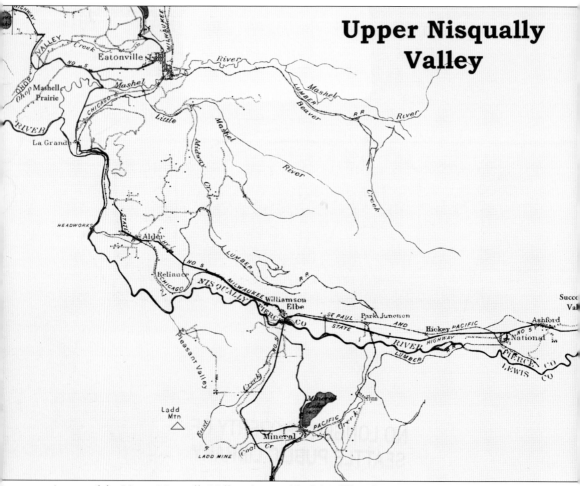

Upper Nisqually Valley

A map of the Upper Nisqually Valley, designed by Matt Waterhouse.

ON THE COVER: The photograph is from the collection of Jim Hale—on the back of the image is the note "Jake's Camp." Who Jake was, the site of the camp, and the photographer are all unknown. It was the practice in the valley to number camps, not to name them. This photograph is older than the memories of the oldest valley residents who have seen it. But they all agree that it could be any one of the dozens of temporary camps located at the time in the woods of the Upper Nisqually Valley.

IMAGES
of America

UPPER NISQUALLY
VALLEY

Donald M. Johnstone and the
South Pierce County Historical Society

ARCADIA
PUBLISHING

Copyright © 2011 by Donald M. Johnstone and the South Pierce County Historical Society
ISBN 978-0-7385-7461-5

Published by Arcadia Publishing
Charleston, South Carolina

Printed in the United States of America

Library of Congress Control Number: 2010938528

For all general information, please contact Arcadia Publishing:
Telephone 843-853-2070
Fax 843-853-0044
E-mail sales@arcadiapublishing.com
For customer service and orders:
Toll-Free 1-888-313-2665

Visit us on the Internet at www.arcadiapublishing.com

CONTENTS

ACKNOWLEDGMENTS

There are many groups, individuals, and families behind a project such as this who deserve thanks. The morning coffee club at the Mineral Market told stories and checked facts. James Kauffsman and Melissa Andrews from the City of Tacoma Public Utilities opened the photograph archives for exploration. Laurie Anderson, the librarian of Columbia Crest School, knows the family connections of the valley and who would have the whole story. The staff of the Northwest Room at the Tacoma Public Library was most helpful in pointing me in the right direction. I am deeply indebted to the Boettcher, Larson, Gronzo, Herrin, Benton, Lyday, Fore, and Engle families for trusting me with their family treasures. A special thanks to Loren and Carolyn Lane for permitting the use of Loren's photographs.

Several individuals and families have been extremely generous in sharing their photographs, as well as their memories and stories. Joe and Betty Sander started me off on this quest with their slide collection. Jim and Edie Hale have been collecting old photographs for many years, and Jim would dive under the bed to retrieve another box of treasures every time he thought of another story. Rick Johnson and Janna Gardner of Ashford Creek Pottery allowed me to search their postcard collection for historic treasures.

Special thanks to my editor Donna Libert of Arcadia Publishing who cheerfully guided me through the whole publishing process. Heidi Waterhouse did a great job organizing the text, and Matt Waterhouse drew the map at the front. Most especially, I'd like to thank my wife, Kathy, and the family who looked at the pictures as they came in and made time for me to do all the work that needed to be done.

I would like to thank Bob Walter and the members of the South Pierce County Historical Society who have listened to my latest discoveries and directed me to new sources of information. All of the photographs without other acknowledgement are from their collections.

INTRODUCTION

The Upper Nisqually Valley is the portion of the Nisqually River Valley from the river's emergence from the national park, down to Alder Lake, then through the Nisqually Canyon and falls, past the old Native American village, and to where the Mountain Highway and the river go in different directions. Three themes are intertwined in the history of the valley: transportation, resource extraction, and travelers and tourists.

The Nisqually River begins its journey to the sea under the glaciers on the south side of Mount Rainier in the Mount Rainier National Park. Some 90 miles later, it forms the Nisqually Reach, home of the Nisqually National Wildlife Refuge. It is the only river in America that begins and ends in protected environments. Along the way, the river runs through the national park, commercial forestland, three hydroelectric projects, a rugged canyon, a major military base, a Native American reservation, and gently rolling farmland.

The Hudson Bay Company established a trading post in 1833 on high ground overlooking the Nisqually estuary and called it Fort Nisqually. They soon had groups exploring the rivers and trading with the Native Americans. They discovered that the indigenous people of the area had an extensive trail system extending along the foothills from the Snoqualmie River in the north to the Mount St. Helens area. The berry fields and elk that flourished near St. Helens were an important part of their subsistence. Another series of trails went east and west through the Cascades. These trails allowed for some trade between tribes of the coast and tribes of the Inland Empire and beyond. One favorite gathering spot was Yakima Park on the north side of Mount Rainier.

One of the area's notable early pioneers was James Longmire. During 1853 and 1854, he led a party of settlers from the east to Walla Walla, where they took the newly surveyed "Walla Walla to Steilacoom Pioneer Citizens Trail." After establishing his homestead on the Yelm Prairie, Longmire partnered with William Packwood in March 1861 to search for a shorter route from Olympia to Yakima. They hired the services of a local Native American guide, Indian Henry. Longmire and Indian Henry had a long work relationship. Indian Henry had a home near where the Mashel and Nisqually Rivers meet. The two men explored much of the west, south, and east sides of Mount Rainier. When Longmire settled at Longmire Springs, Indian Henry continued to explore higher up the mountain. There are several areas on the mountain named for Indian Henry.

By the 1860s, settlers started moving south from Tacoma and upriver from the Yelm area. The first tourists to the mountain arrived soon after. The first recorded ascent of the mountain was in 1870. Over the years, as more settlers arrived, they shared in the abundance of game and resources with the first inhabitants but started clearing the forest so they could plant grasses for their animals. Industries developed, so did the trains and roads. With the establishment of Mount Rainier National Park in 1899, even more visitors came. Over the next 100 years, forestry, farming, and tourism became the story of the valley.

The Tacoma Eastern Railroad arrived in the valley in 1902, and by 1910, the line was completed to Morton. The arrival of the train heralded a new era for the valley residents. The rails brought new opportunities for the valley residents and landowners. Those with timber holdings now had a way to get their long-growing crops to market. Sawmills, small and large, popped up all over the valley. Exploration for minerals lead to the discovery of coal, copper, arsenic, and cinnabar in commercial amounts. The railroad also gave the city of Tacoma access to the area and allowed them to bring together the men and materials needed to develop the hydroelectric resources of the La Grande area.

There is some confusion as to whether it is "National Park Highway" or the "Mountain Highway." Before 1917, the route from Tacoma to Ashford was the concern of Pierce County and was known as the Mountain Highway. In July 1917, the state legislature approved expenditures to improve the route and to help make the transition from horse-drawn vehicles to motorized cars, trucks, and busses. They renamed the route the National Park Highway and later gave it the designation of Primary State Highway 5. In 1963, the state revised all of their route numbers to accommodate the interstate system. The Mountain Highway was redesignated to State Highway 7, with terminals in Tacoma and Morton. The section of the highway from Elbe to the Nisqually Park entrance was designated as State Highway 706. So looking at a map one still might see The National Park Highway, The Mountain Highway, or Highway 7 or 706, and they all refer to what locals know as the Mountain Highway.

The book is generally organized to follow the route of the railroad. In some of the photograph captions, there are references to the state highway milepost markers. This is so that the reader can compare the historical photograph to the view today. The references are Highway 7 (Hwy 7), Highway 706 (Hwy 706), Mineral Hill Road (MHR), Mineral Road North (MRN), Mineral Road South (MRS), Mineral Creek Road (MCR), and Mount Tahoma Canyon (MTC).

One

OHOP PRAIRIE, MASHEL PRAIRIE, AND PACK FOREST

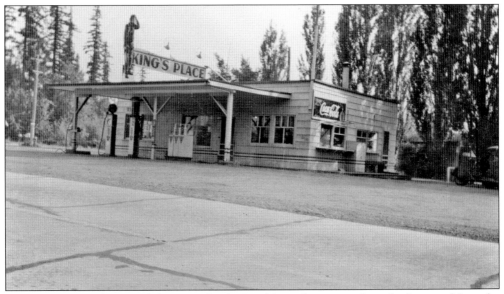

The Mountain Highway and the King-Flander Road formed a corner where the farm road from the Ohop Valley farms and the roads that served the many dairy farms around Silver, Kreger, and Cranberry Lakes intersected. From there, farmers could get their goods to Tacoma and Eatonville.

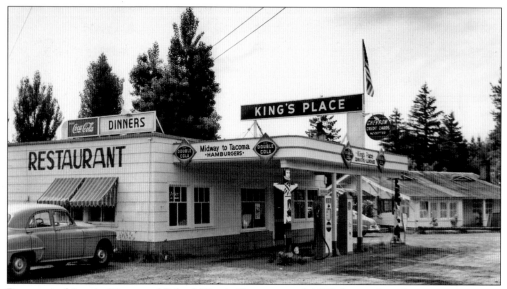

Roscoe and Lottie King established King's Place around 1929. It combined a service station, café, and convenience counter in a style typical of several wayside stops along the highway. The family-owned business offered gas, oil, water, and windshield washing for the car. During the war years, when Jessie and Madora Dawkins owned the store, it was open from around 6:00 a.m. until the money drawer exceeded $10 for the day. In 1948, Leif and Margit Thorvaldson bought King's Place from the Kellers. In the café area, the travelers found clean restrooms, coffee, meals, snacks, cold soda pop, camera film, and tourist souvenirs. This photograph is from around 1941. (Hwy 7, milepost 31.8.) (Courtesy of Madora Dawkins.)

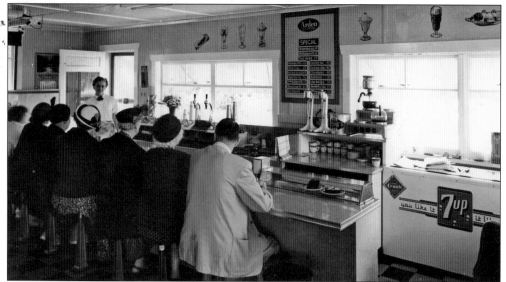

The counter sat around 10, and there was table seating for another 12. The Thorvaldson's daughter, also named Margit, remembers that in the early 1950s her mom served breakfasts, full dinners—including trout, steak, or Norwegian meatballs—and homemade pies—wild blackberry, banana cream, and apple. After several more owners put their stamp on it, the "Place" was removed in the late 1960s or early 1970s. This photograph was taken around 1954. (Courtesy of South Pierce County Historical Society.)

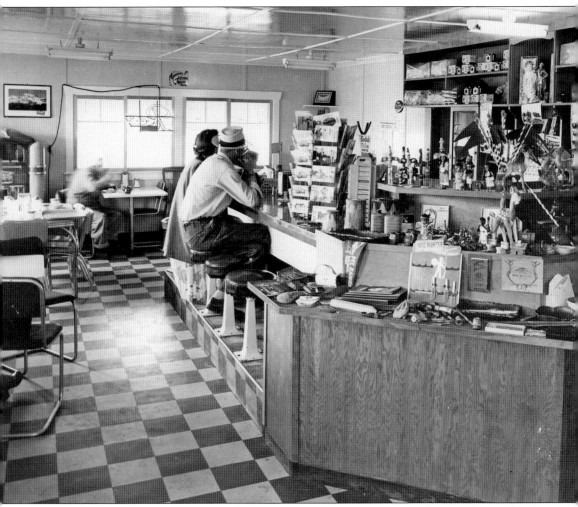

The inside of King's Place in 1948 shows retail space that could supply tourists with everything from children's pocket knives and postcards to filling lunches.

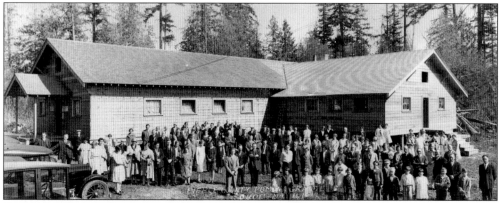

Grange members gather at the newly constructed Ohop Grange building. This *c.* 1926 "Pomona" included Grange members from all over the county. (Courtesy of Ohop Grange.)

The Ohop Grange was organized in 1924 after an initial meeting at Edgerton schoolhouse, and the building was completed in 1927. The Grange is a national organization formed to provide service to agriculture and rural areas on a wide variety of issues, including economic development, education, family endeavors, and lobbying for legislation designed to assure a strong and viable rural America. The Grange soon became the center of community life for the families of the Ohop Valley and those living west of the Mountain Highway. Here the community came together to celebrate the golden wedding anniversary of Mr. and Mrs. Herman Anderson around 1929. (Hwy 7, milepost 31.7.) (Courtesy of Ohop Grange.)

This is a popular view from Ohop Bob. It was a restaurant and meeting site. The site was first developed by a cycle club to support members who rode out from Tacoma. Around 1914, the site was further developed by the Washington Automobile Club to serve their members as they undertook the two-day trip from Tacoma to Longmire Springs. The luncheon and dinner meals were highly rated and a favorite of the upper-class travelers from Tacoma and Seattle. One diner reported that the chicken was still living when he ordered his meal. More than one party found that their trip to the mountain ended at Ohop Bob. The restaurant served the motoring public from early 1922 until it burned in May 1965. (Hwy 7, milepost 31.5.) (Courtesy of Rick Johnson and Ashford Creek Pottery.)

The Inland Revenue Service, District of Washington, had their annual banquet for employees and their families at Ohop Bob's Tea House in 1922. Everyone is wearing festive party hats for the occasion. Two years later, it became Ohop Bob's. (Courtesy of Tacoma Public Library.)

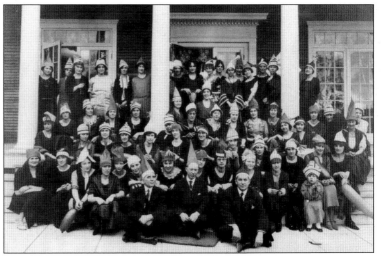

The word "Ohop" is said to be a Native American adjective meaning "pleasant," and "Bob" is an old Scottish term, often used instead of the word "top." Thus "Ohop Bob" means "Pleasant

Top." The site was first developed by a cycle club to support members who rode out from Tacoma. (Courtesy of Rick Johnson and Ashford Creek Pottery.)

Pioneer Farm Museum and Ohop Indian Village is 0.6 miles up the Ohop Valley Road from the Mountain Highway. The farm has a number of historic buildings preserved from when the valley was settled late in the 19th century. Visitors explore a one-room schoolhouse and learn about the chores pioneer children were responsible for, including grinding grains, churning butter, scrubbing laundry, carding wool, gathering eggs, milking, and checking on all the animals. (Hwy 7, milepost 30.1.) (Courtesy of Pioneer Farms.)

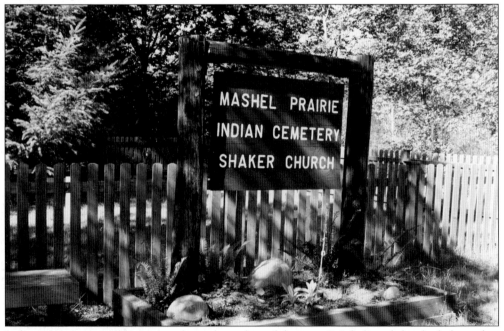

Indian Henry was well known to the early settlers of the area. It is believed that he belonged to an Eastern Washington native band. He brought horses across the Cascades from the Columbia Basin to trade with early settlers in the Puget Sound region. James Longmire from Yelm hired Indian Henry as a guide to the Native American trail system and together they explored what was to become Mount Rainier National Park. Much of the Indian Henry homestead is included in the new Mashel Prairie State Park. (Hwy 7, milepost 29.4, then 1.7 miles.) (Photograph by Heidi Waterhouse.)

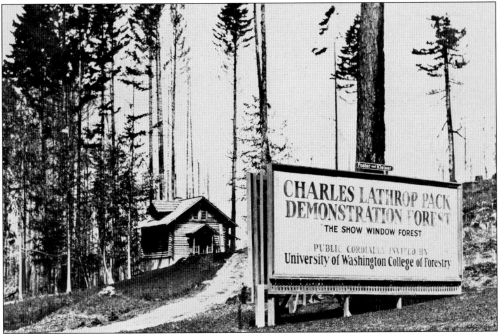

In January 1926, wealthy Ohioan Charles L. Pack granted the University of Washington School of Forestry enough funds to purchase 160 acres to be used as an experimental forest station. Before the transaction was completed, Pack donated funding that allowed the university to purchase a total of 334 acres of forestland for $9,222, or about $28 an acre. One of the first structures on the new campus was the manager's cabin, which was completed in 1927. The site of Pack Forest was chosen partially because it was close to the Mountain Highway. The original grant specified that the forest's uses be visible and open to the public. (Courtesy of University of Washington Pack Forest.)

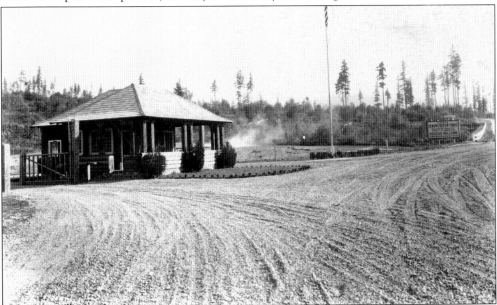

Another one of the first structures on the new Pack Forest campus was the gatehouse, completed in 1930. (Courtesy of University of Washington Pack Forest.)

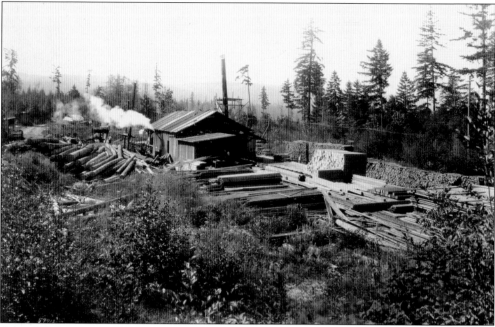

One of the primary goals of the Pack Forest was that it be self supporting. A small, used lumber mill was purchased and installed on the property. The mill used timber cut on the property, milled it, and then used it for construction of the campus buildings or sold it for use on the main campus in Seattle. (Hwy 7, milepost 26.7.) (Courtesy of University of Washington Pack Forest.)

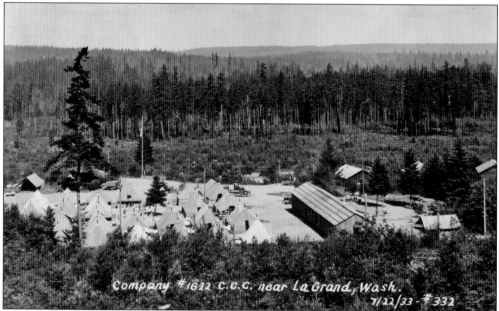

Company #1622 C.C.C. near La Grand, Wash.
7/22/33 - #332

During the Great Depression, Pack Forest hosted Company No. 1622 of the Civilian Conservation Corps (CCC). The CCC crews built the dining hall, classrooms, bunkhouses, staff housing, and roads. Conservation Corps members also worked on research projects in conjunction with students and faculty. Visitors today can still see some of these research projects and hike the trails built by the CCC. (Courtesy of University of Washington Pack Forest.)

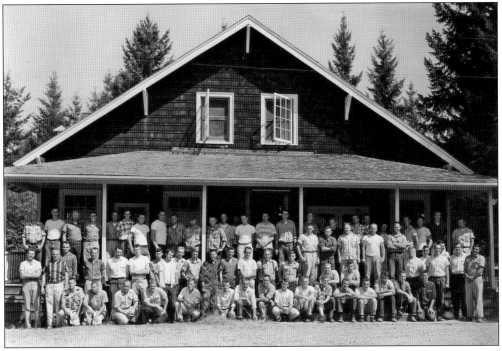

From the 1930s to the 1980s, students from the School of Forestry spent at least one quarter at Pack Forest. They had classes in practical aspects of their profession. They learned to use the tools of loggers and engineers and how to work in a forest environment. (Courtesy of University of Washington Pack Forest.)

To this day, Pack Forest is an experimental field station of the College of Forest Resources of the University of Washington. It is open to the public and has miles of hiking trails, nature resources, and education facilities on an expanded campus of 4,300 acres. Forestry students at the University of Washington attend classes at Pack Forest. The education includes both classroom instruction and hands-on learning. (Courtesy of University of Washington Pack Forest.)

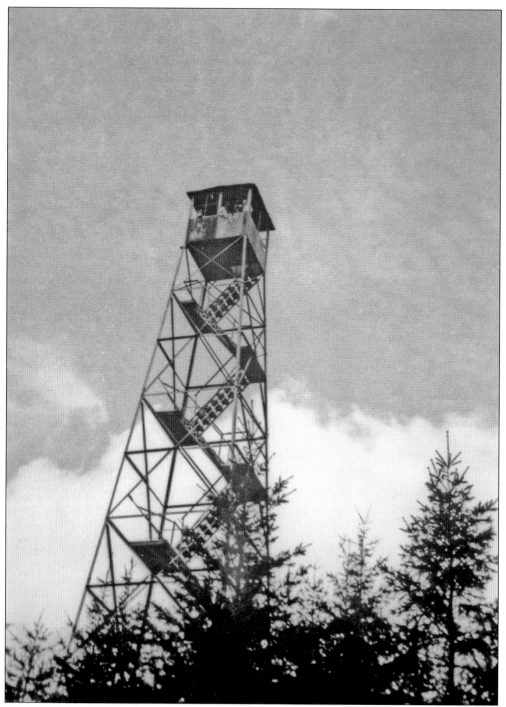

This fire lookout was located on the highest point of the forest. It served multiple functions: it helped protect the forest and surrounding lands from fire, and it allowed the students to learn the skills needed to operate a lookout. The tower was removed in the early 1980s. The site still has a spectacular view of Mount Rainier, and Pack Forest still welcomes the public. (Courtesy of Joe Sander.)

Two

LA GRANDE AND NISQUALLY CANYON

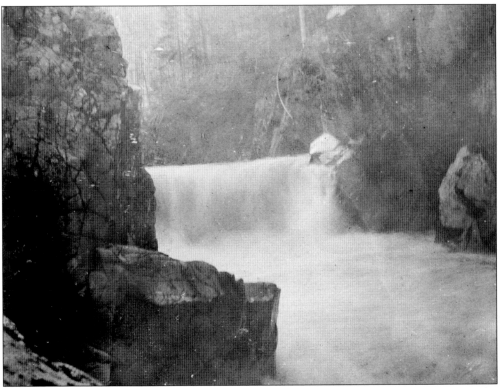

This chapter describes the Nisqually Valley—originally a popular tourist destination—the hydroelectric projects that changed it and gave power to the growing cities, and the original and rebuilt town of Alder.

In 1900, La Grande was little more than a spectacular river canyon, a waterfall, a few scattered cabins, and great dreams. John L. McMurray, a rising lawyer from Tacoma, started buying land on what he hoped would be the route of the proposed Tacoma Eastern Railroad. In January 1904, the railroad arrived, and La Grande became less sleepy. In 1905, George Thornton surveyed the route of the Mountain Canyon Road and McMurray donated land for the Nisqually Canyon Road. (Hwy 7, milepost 31.8.) (Courtesy of Tacoma Public Utilities.)

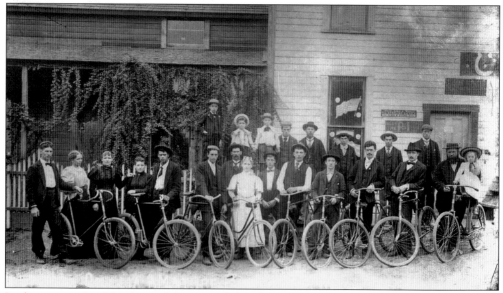

In this era, much of the demand for expanded and improved roads came from bicyclist and cycle clubs. In the La Grande area, the trains arrived in 1902. The clubs wanted improved roads so they could ride up from Tacoma, enjoy the falls, and return home on the evening train. This group, identified as the Orilla Amateur Bicycle Club, sets out for a day's adventures. (Courtesy of Tacoma Public Library.)

Picnic grounds with a swing bridge and trail system were soon established to support the visitors who came by bike or train. (Courtesy of Jim Hale.)

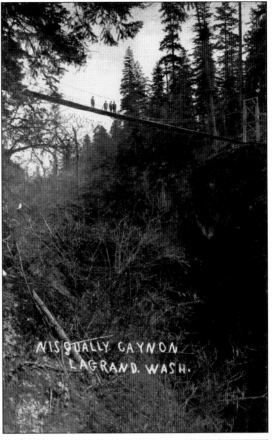

The picnic grounds were expanded to meet the constantly increasing demand. They soon included guest cabins and expanded trails. By 1912, the Canyada Lodge was under construction. John McMurray built the lodge for the grand sum of $92,500. The magnificent three-story structure had a unique oriental style. It drew visitors from across the country and around the world. This reprinted postcard is from the early 1920s and lists the second owner, E. J. Leak, as proprietor. On March 14, 1927, the lodge burned. A second lodge was soon built and it served the motoring public rather than cyclists and train riders. The second lodge burned on January 28, 1966. (Courtesy of Rick Johnson and Ashford Creek Pottery.)

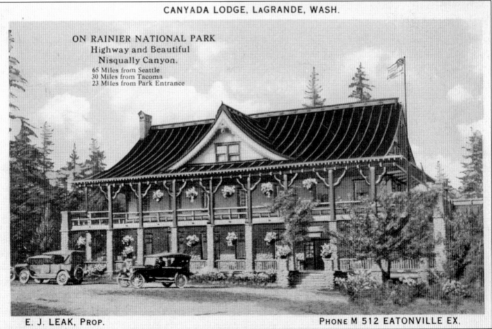

CANYADA LODGE, LaGRANDE, WASH.

ON RAINIER NATIONAL PARK
Highway and Beautiful
Nisqually Canyon.
65 Miles from Seattle
30 Miles from Tacoma
23 Miles from Park Entrance

E. J. LEAK, PROP. PHONE M 512 EATONVILLE EX.

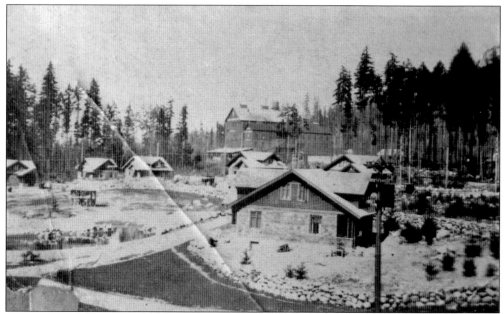

With the arrival of Tacoma City Light crews in 1909, La Grande entered its boom period. A post office was established in 1910, and a rough road was opened to Alder and then improved. Up the railroad tracks toward Eatonville, a paint pigment site was developed. In 1912, the dam started transmitting power to Tacoma. In 1916, work began on the American Nitrogen Plant. (Courtesy of Dave Smith.)

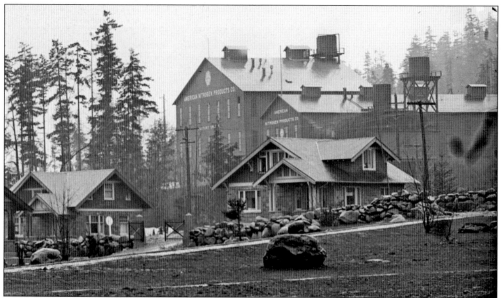

Even at its peak, La Grande was never a large community. One report tallies the population in 1913 at 59 residents, almost all employees of the city of Tacoma. There is no record of La Grande ever having a school, so many students boarded elsewhere or commuted to Eatonville. At this time, La Grande was reported to be the first "all-electric" community in the world. A close inspection of the photograph will show that none of the homes have a chimney, proving all heating and cooking was done by electricity. (Courtesy of Tacoma Public Utilities.)

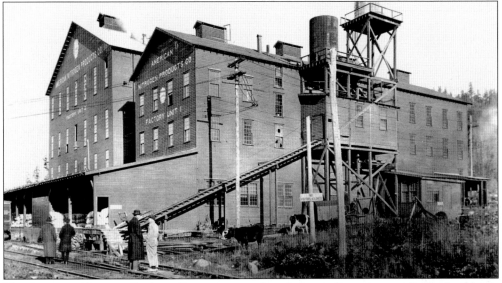

The American Nitrogen Products Company started producing sodium nitrate pellets in La Grande in 1916. The product is also known as saltpeter and is used in a number of chemical processes and as a component of explosives and as a fertilizer. The La Grande plant was the first commercially viable plant in the country. This photograph appeared in a newspaper article of the era. The photograph shows both plants one and two, the electrical service, and bags of pellets on the loading dock ready for shipment. (Courtesy of David Smith.)

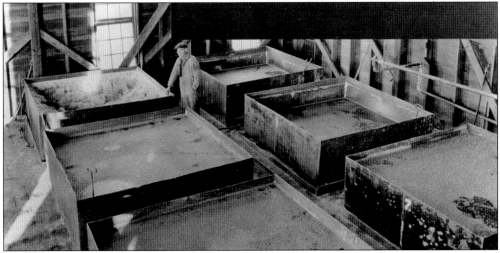

The plant was the first of its kind in the United States. The technology was a patented process of F. S. A. Weilgoiaski, a Norwegian chemical engineer. The process used a nitrogen atmosphere furnace, electrolysis, and a continuous-flow, high-pressure technology. It was a further development of the Haber process, also called the Haber-Bosch process; this new process was so significant that Haber and Bosch were later awarded Nobel prizes, in 1918 and 1931 respectively. The process "caused a nitrogen fixation reaction of nitrogen gas and hydrogen gas, over an enriched iron or ruthenium catalyst," which is used to produce ammonia. The ammonia was then further processed into small pellets that could then be transported to market. Workers appear to be readying the electrolysis solution containing the catalyst that will then be placed in the furnaces. (Hwy 7, milepost 26.0.) (Courtesy of Dave Smith.)

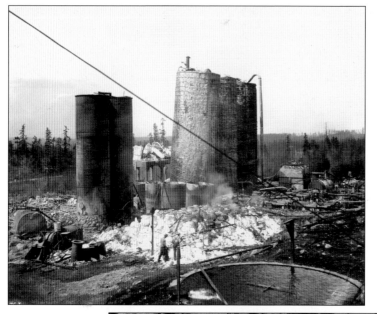

The plant was located in La Grande for several reasons: to take advantage of the electrical power produced locally, the railroad there would transport the volatile product to market, and isolation for the safety of others. Ammonia gases might escape, and the threat of fire and explosion were high. The fears of fire were well founded, as a fire destroyed the plant on May 4, 1927. (Courtesy of Dave Smith.)

It is unknown when the La Grande store opened, as it may have been part of John Murray's picnic grounds. A post office was established in June 1910 and still serves the community 100 years later. This watercolor painting by Janice Isom captures how the store looked in the early 1980s.

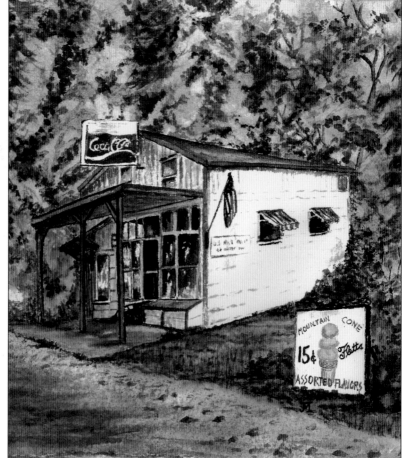

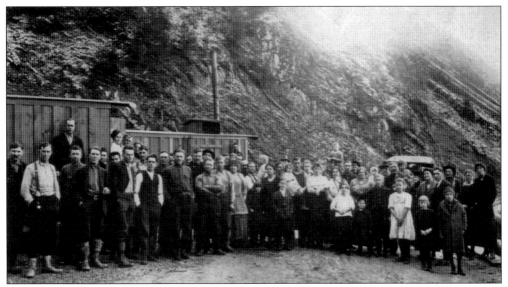

The work on the Nisqually Canyon Road took a number of years. Torval Peterson, the local county road superintendent, blazed a trail along the route shortly after the railroad entered the valley in 1902. According to state law then, "Every male over 21 years of age has to pay the road toll tax or pay by labor of $4 a day or two days of labor. Each man has to provide his own tools (axe, shovel, or pick) as directed by the Superintendent when the Superintendent needs them out for work." This group of Ohop area residents is working on the Canyon Road so they could vote in upcoming elections. As soon as the work on this 5-mile section of the road was complete, it was included in the Mountain Highway, or National Park Highway. (Hwy 7, milepost 26.)

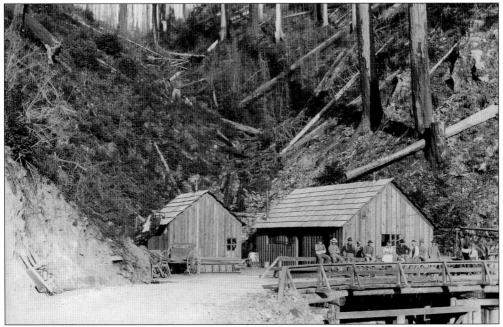

This is a road construction camp in the canyon near where a rock face was blasted in 1910. Victor Interbit, in the lower right corner, is holding the horse's bridle. For many years, there was a highway repair depot located here. (Hwy 7, milepost 24.6.)

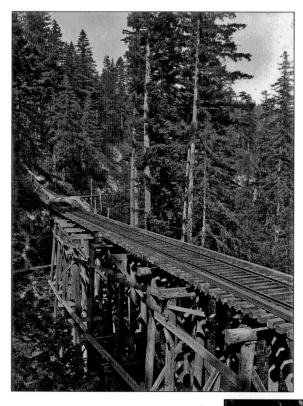

Much of the original riverbed was flooded by the construction of the dams on the river. All that remains to be seen of this spectacular canyon are the photographs taken before the construction of the dams in 1912. All of the bridges, tunnels, and trails have been removed. (Courtesy of Tacoma Public Utilities.)

What the visitors cannot see from the highway is the 200- to 400-foot deep, narrow, steep-sided canyon that the river has carved through rock. The passage is so deep, rocky, and dangerous, that the Native Americans of the area took an extra day of travel to avoid it. The term La Grande was applied to a 200-foot waterfall discovered by Hudson Bay traders from Fort Nisqually. (Courtesy of Tacoma Public Utilities.)

Three

THE NISQUALLY PROJECTS

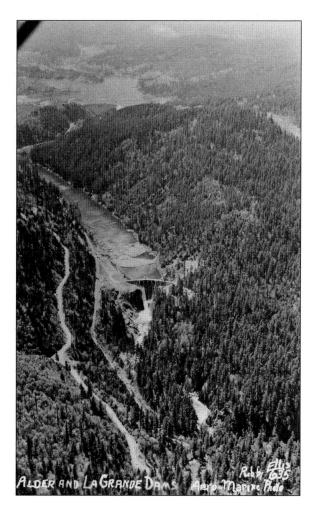

In 1907, Tacoma was having a problem securing a reliable supply of economical electrical power. After a heated debate, voters approved the city's entry into electrical production and distribution. The first project started in 1910, with the second project being completed in 1944. This view shows the Nisqually Canyon after the work was completed. (Courtesy of Tacoma Public Utilities.)

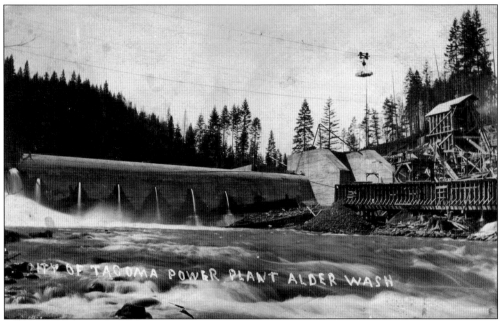

Construction on the project started in February 1910. The containment dam was used to ensure that the dam could operate during dry periods. As a glacier feeds the Nisqually, the reservoir did not have to be very large. The dam was 225 feet long and rose 35 feet. (Courtesy of Jim Hale.)

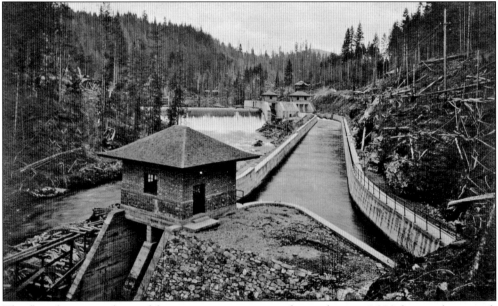

The flow that was to be used for power generation was diverted into a 1,300-foot settling canal, which removed silt from the water. Then the water flowed into a tunnel that was more than 2 miles long. The gatehouse seen here allowed the settling canal to be flushed of the built-up silt. The flow then entered a nearly 2-mile-long tunnel on the south side of the Nisqually River. The tunnel was from 10 to 12 feet tall and had cement lining on the floor and partially up the sides. Welsh coal miners were the contractors for the tunnel portion of the project. (Courtesy of Tacoma Public Utilities.)

The water was then forced into a pipe bridge that carried it across the valley hundreds of feet above the canyon floor. Then it entered another 1,200-foot-long tunnel and spilled into the powerhouse reservoir (fore bay), which held 3.2 million gallons—approximately one day's requirements. (Courtesy of Tacoma Public Utilities.)

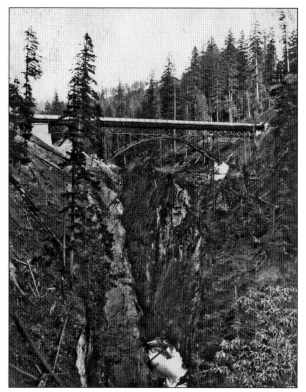

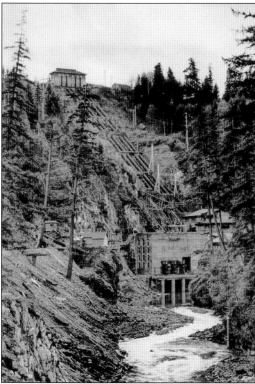

From the fore bay, the water dropped into four large pipes that were 5 feet wide and carried water to the powerhouse 410 feet below. In the powerhouse, the four sets of Allis-Chalmers turbines and generators each produced 8,000 horsepower. The project was completed exactly as specified in the original plans, on time and on budget. (Courtesy of Tacoma Public Utilities.)

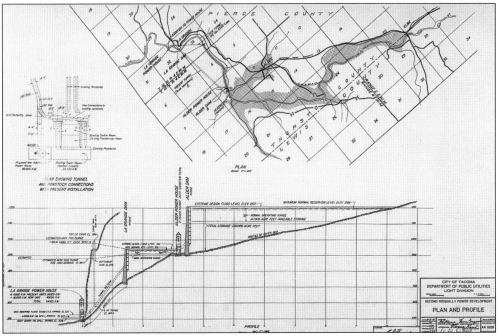

This drawing is the plan for the original stage two of the Nisqually project. It was part of the city's community education on the project. (Courtesy of Tacoma Public Utilities.)

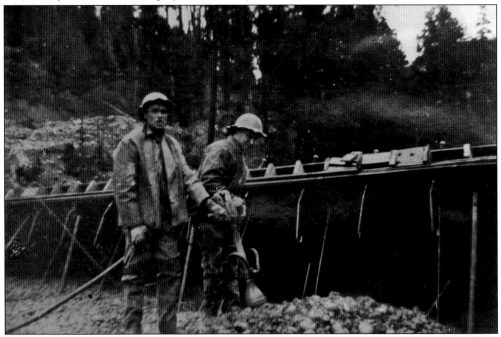

Undertaking a project of this size during a war had a number of pluses and minuses. Support for the war effort helped to speed land acquisition, planning, and some local construction. Concerns about the availability of steel, cement, gravel, railroad ties, and workers added to the construction headaches. Burt Hass and a coworker are pictured preparing to pour concrete. (Courtesy of Madora Dawkins.)

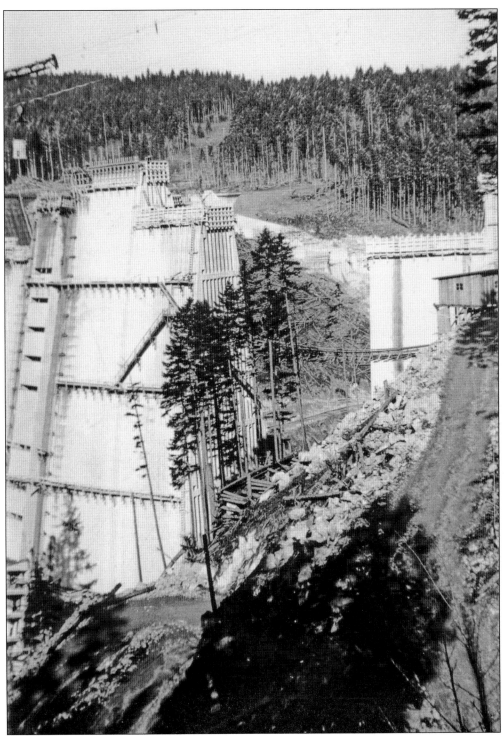

This section of the new dam could not be started until work on relocating the railroad was complete. Here is part of the old track in the lower center. On the face of the dam are ladders, scaffolding, and conveyers. (Courtesy of Joe Sander.)

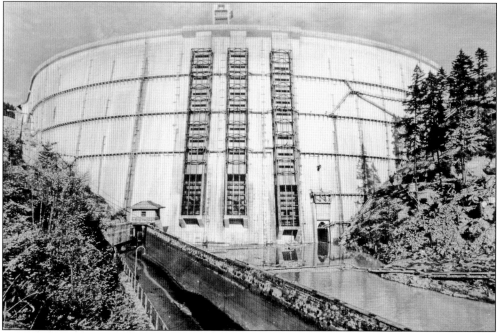

Nearly completed, the gates that control flow to the turbines are clearly visible, and the derrick for maintaining the dam is on the top of the dam. The canal on the left is from the old diversion system. (Courtesy of Joe Sander.)

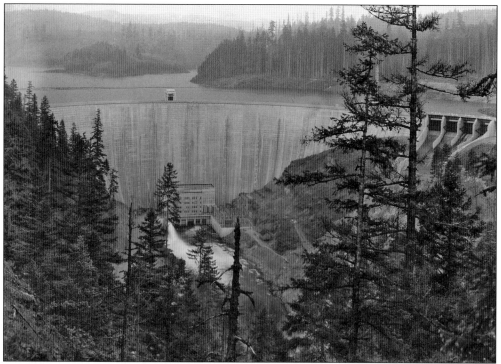

The reservoir behind the new Alder dam started filling in January 1945. The new powerhouse is in the lower center, and the overflow spillway is on the right. (Courtesy of Tacoma Public Utilities.)

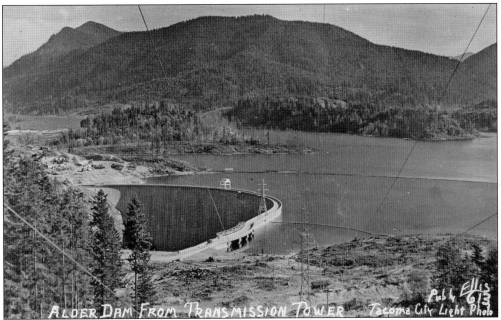

This view of the dam and reservoir was photographed from the transmission tower on the south shore of Alder Lake. (Courtesy of Tacoma Public Utilities.)

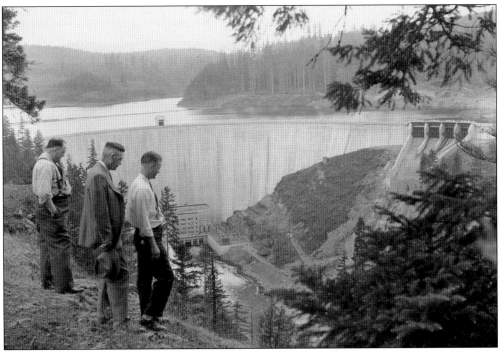

Members of the dam team consider where to place the recreation areas mandated by the new contract for the dam in the 1970s. These recreational areas came to include Sunny Beach Point, Alder Park, and Rocky Point. (Courtesy of Tacoma Public Utilities.)

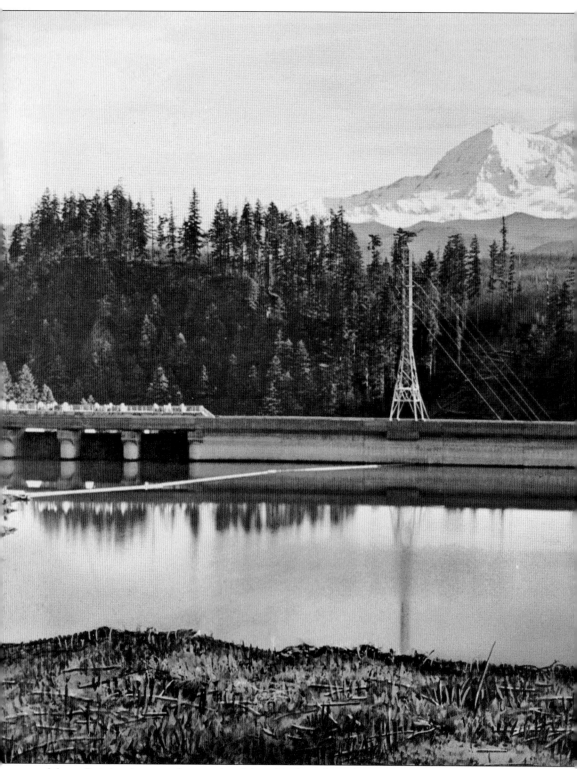

Mount Rainier rises over the completed dam. To the right is the construction camp, and just under

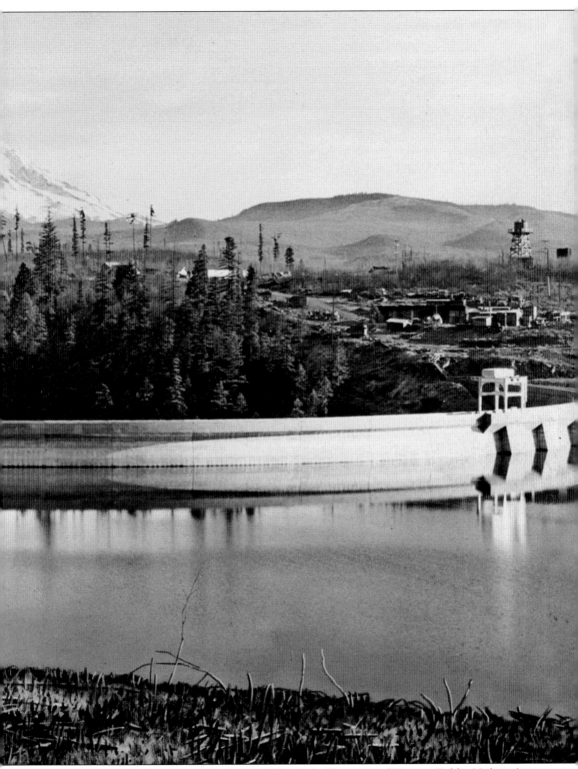

the mountain is the location of the future Alder Park. (Courtesy of Tacoma Public Utilities.)

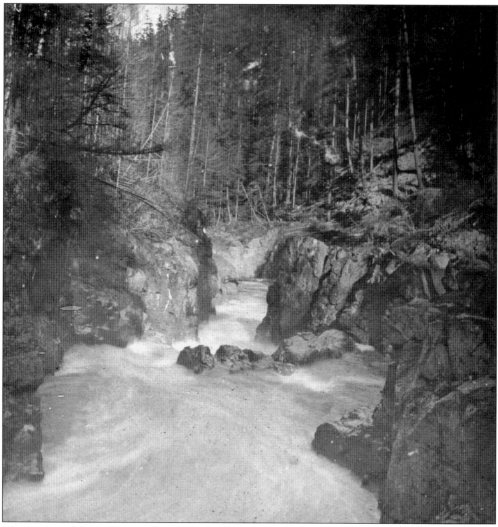

This canyon is now drowned by the hydroelectric power station. The natural beauty of the site has been preserved in photographs by the local residents, and the power of the river lights Tacoma now and into the future. (Courtesy of Boettcher family.)

Four
ALDER AND LILIE DALE

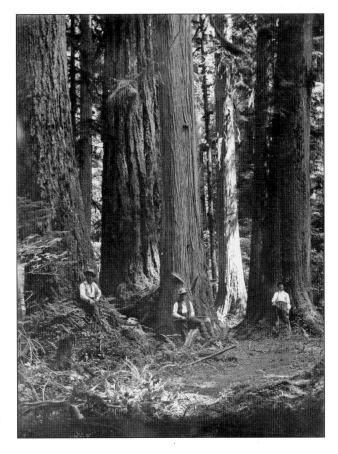

The community of Alder dates back to 1895, and the post office was established in 1902. The early settlers had difficulty visiting each other due to the mass of fallen trees that covered the ground. The settlers calculated that there was a major fire in the area around the 1760s. With so many trees on the ground, in 1895, the men of the community spent two weeks cutting trails from each homestead to a proposed school site. Forests like these were hard to traverse.

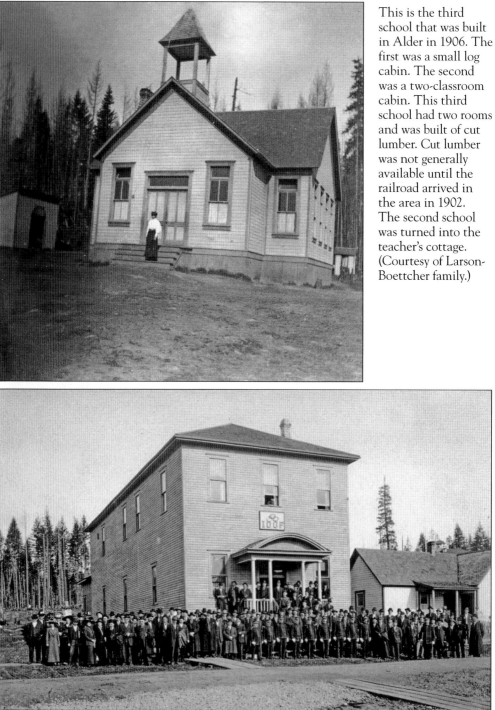

This is the third school that was built in Alder in 1906. The first was a small log cabin. The second was a two-classroom cabin. This third school had two rooms and was built of cut lumber. Cut lumber was not generally available until the railroad arrived in the area in 1902. The second school was turned into the teacher's cottage. (Courtesy of Larson-Boettcher family.)

This picture is of a district meeting of the International Order of Odd Fellows (IOOF) in Alder, on October 26, 1912. The Odd Fellows started in England in 1688. The Odd Fellows's duty is "to visit the sick, relieve the distressed, bury the dead, and educate the orphans." Both Alder and Elbe had IOOF chapters. (Courtesy of Joe Sander.)

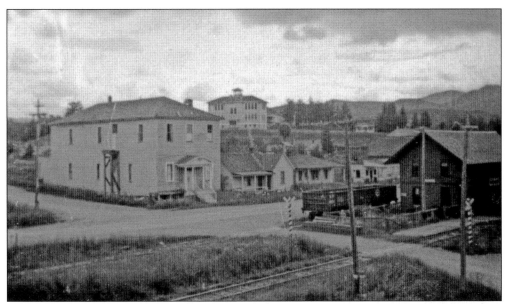

This 1920s view of Alder shows the fourth school on the hill behind town; the IOOF building is on the left and the depot is on the right. The road to the right leads to the mill and river. (Courtesy of Joe Sander.)

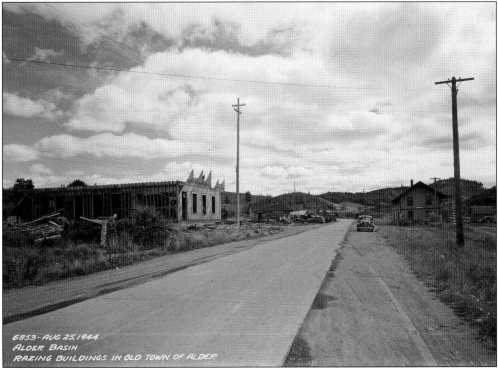

As the lake behind Alder dam started to fill, the Alder town site was cleared. Four buildings were saved: the Presbyterian church, the top story of the school, the Alder store, and a newly built private residence. As seen here, the rest were demolished and what could be was recycled. This photograph was taken in August 1944. (Courtesy of Tacoma Public Utilities.)

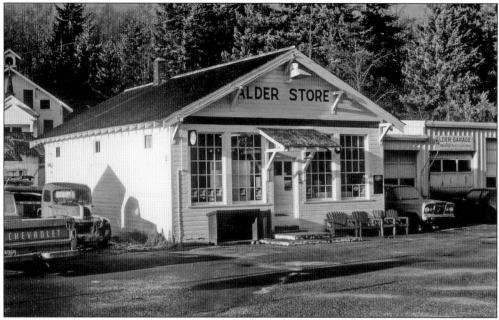

The Alder Store was one of the few buildings saved from the old town site. In the mid-1970s, the store had given up the gas pumps but continued to provide mechanic services. The store burned shortly after this picture was taken. (Highway 7, milepost 22.5.) (Photograph by Loren Lane.)

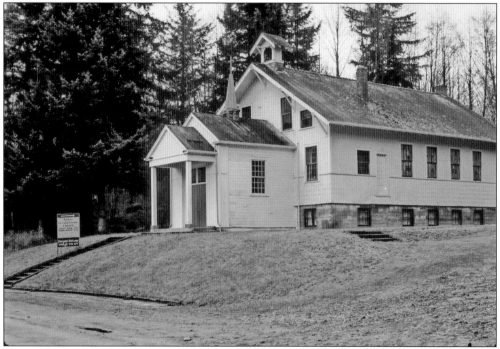

The Alder Presbyterian Church was established in 1920. Over the next few years, the Elbe congregation united with the Alder congregation to serve the needs of the community. The building was moved to the current site in 1944 as part of the Alder dam project. (Photograph by Loren Lane.)

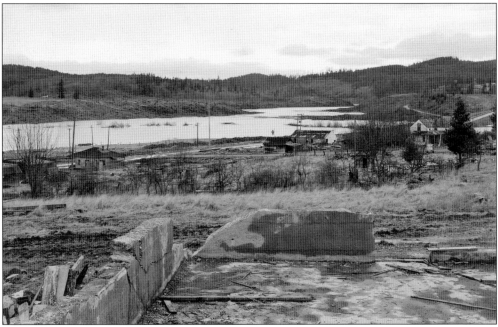

The foundation of the old Alder school can still be seen on School House Island, which can be reached during low water from Sunny Beach Point. The school was two stories with a basement and foundation. It had four classrooms and served first through eighth grade. High school students attended classes in Eatonville. (Hwy 7, milepost 21.7.) (Courtesy of Tacoma Public Utilities.)

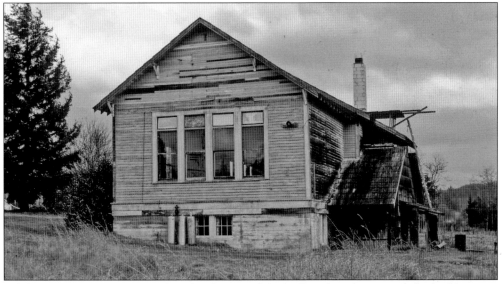

When it came time to move the school, it was lifted off its foundation and the building was moved to a new site with a new foundation. When the community started to refit the building, they discovered significant damage to the roof and upper floor. These were removed, and a new roof was installed. With the opening of the new Columbia Crest School near Ashford, the school was closed. The building started to deteriorate until it became the Alder Community Center. Community members have restored the building, and it is used for a number of activities. (Hwy 7, milepost 22.3.) (Photograph by Loren Lane.)

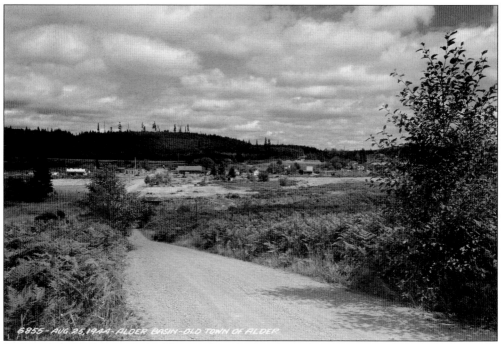

In August 1944, the town of Alder was disappearing fast. The trains were already gone, and the new highway can be seen on the far hillside. The photographer was probably on the south side of the lake. (Courtesy of Tacoma Public Utilities.)

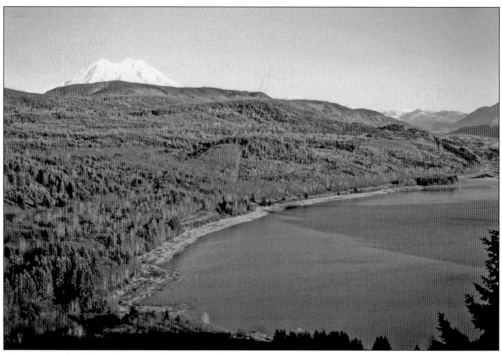

This view of Alder Lake was taken from the top of Lillie Dale hill. This is a peninsula that juts out into the lake. (Hwy 7, milepost 22.3.) (Courtesy of Joe Sander.)

This style of construction relied on local materials. Cedar splits very well on the long grain, and one log can be split into several of these planks. A rudimentary frame was constructed, and the cedar planks were nailed to it. This was much more efficient than building the log houses that pioneers were using. Settlers in the Northwest required less insulated buildings than settlers in the Midwest. (Courtesy of Boettcher family.)

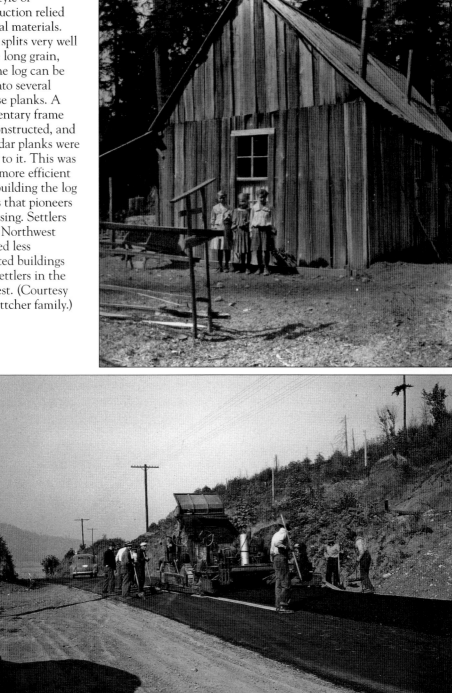

As part of the Nisqually Project, major sections of the highway had to be relocated to above the new reservoir level. These workers are laying pavement between Alder and Elbe. (Courtesy of Tacoma Public Utilities.)

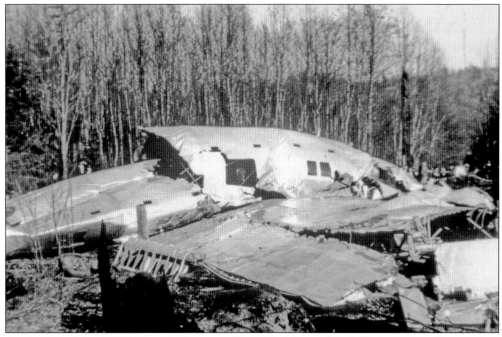

On Saturday, March 18, 1939, at 1:18 p.m., traffic on the National Park Highway slowed as travelers saw an airplane fall apart in the air and crash into a hillside near Alder. It was a prototype Boeing aircraft. (Courtesy of Joe Sander.)

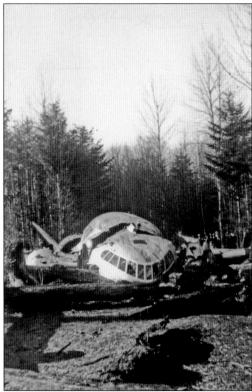

The Boeing model 307 "Stratoliner" was the first pressurized commercial passenger aircraft. It was designed to carry passengers long distances "above the weather" at 10,000 feet or more. The plane was on a sale demonstration flight with Boeing and KLM employees aboard when it broke apart in midair and crashed near Alder. (Courtesy of Marie Fore Estate.)

The victims were test pilots Harlan Hull, Julius Barr, Earl Ferguson, and William Doyle; Boeing staff John Kylstra, Harry West, Ralph Cram, and Benjamin Pearson; KLM representatives Peter Guilonard and A. G. Von Baumhauer. (Courtesy of Joe Sander.)

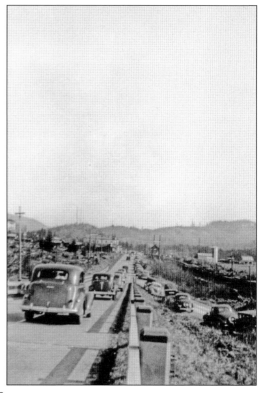

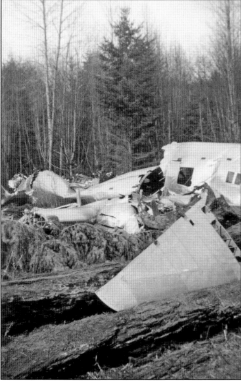

The plane was a civilian version of the army's B-17, so the army and Boeing scoured the crash site to remove all the debris. Within two hours, the largest section remaining had been moved to the Ashford Tavern parking lot. Within four hours, the first federal agents began searching the valley. The government did not want this new technology falling into unfriendly hands. (Courtesy of Joe Sander.)

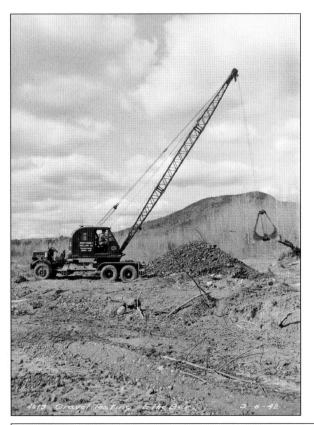

When the Tacoma City Light crews surveyed the proposed lake bed, they discovered a glacial moraine from the Nisqually Glacier. The moraine was developed into a gravel pit, which provided all of the aggregate needed for the construction of the dam, the relocation of the highway, and ballast for the new rail bed. (Courtesy of Tacoma Public Utilities.)

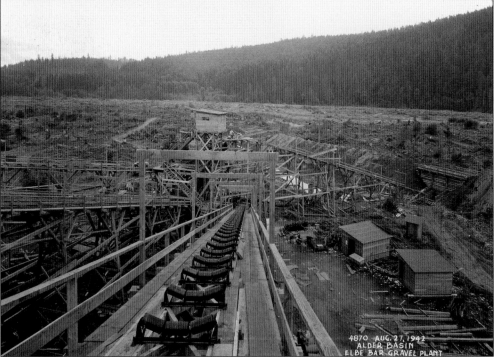

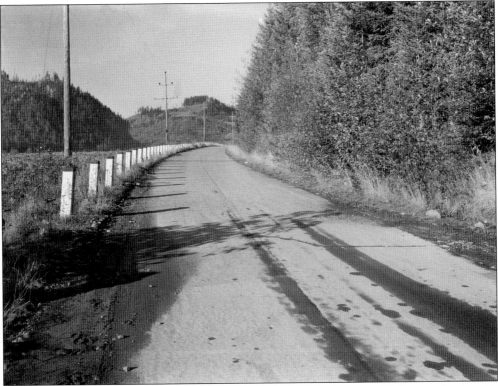

These two views highlight the improvements made to the Mountain Highway when it was relocated. Note the new guardrails, shoulders, stripping, and the improved sight lines on the uphill side. (Hwy 7, milepost 17.7.) (Courtesy of Tacoma Public Utilities.)

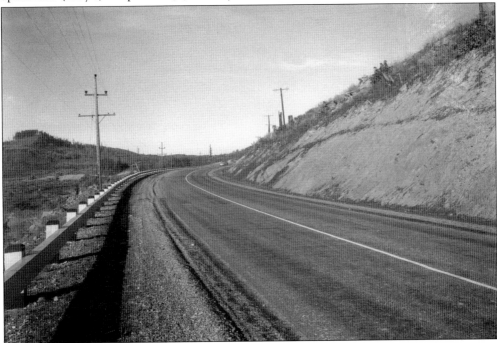

As part of the second phase of the Nisqually Project, the railroad that once came up through the Nisqually Canyon was rerouted out of Eatonville and generally paralleled the Eatonville-Alder cutoff road. A fill-bed was laid alongside the railroad, and the road was placed over the filled portion. Unbeknownst to the engineers, they disturbed a spring under the road fill. The spring causes portions of the fill to slough off. (Eatonville-Alder Cutoff Road, milepost 5.1.) (Courtesy of Tacoma Public Utilities.)

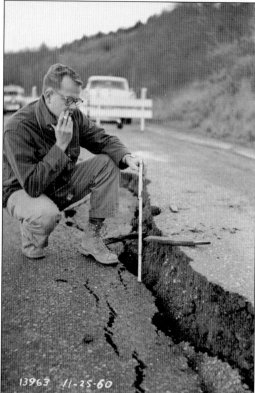

This sloughing soon became a chronic problem. In 1960, a road engineer noted that a portion of the road had dropped almost a foot. The "patch" was to lay new layers of asphalt until the road was sufficiently level. Locals still ask, "How many feet deep is the asphalt in that section of the road?" The road is still patched once or twice a year as needed. (Courtesy of Tacoma Public Utilities.)

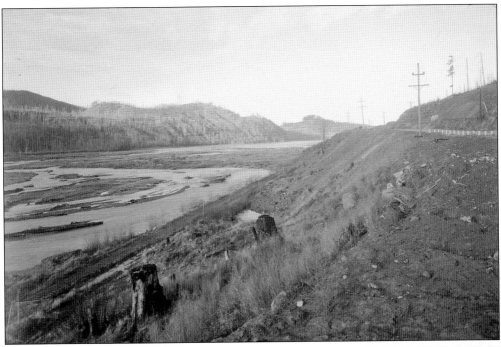

The reservoir was designed to have over 200,000 acre-feet of capacity. There was to be a 50-foot elevation from the lake bottom to the roadway. A lahar on Kautz Creek on October 3, 1947, was triggered by heavy rainfall on the mountain. The flood eroded the Kautz glacier and carried fast water and debris down the valley until it slowed at the newly created Alder Lake. On the way, the Nisqually-Longmire Road was buried in 28 feet of debris. This and the normal settling of silt from the glaciers soon started filling the reservoir faster than anticipated. (Courtesy of Tacoma Public Utilities.)

This 1956 photograph shows over 20 feet of silt deposited just down river from Elbe. (Courtesy of Tacoma Public Utilities.)

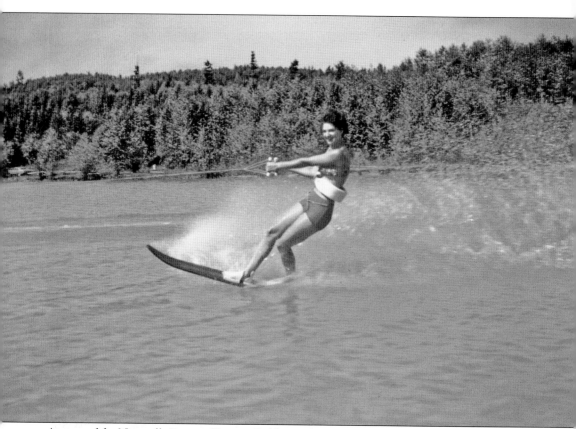

As part of the Nisqually Project, Tacoma Public Utilities provided recreational areas at the Alder Lake Reservoir. A water-skier uses the reservoir during the summer when the water is full. In the winter, when the reservoir is drawn down to provide power, the beach is less appealing, but few residents swim in the winter. (Courtesy of Joe Sander.)

Five

RELIANCE AND ELBE

Elbe is the oldest of the valley communities. It had multiple businesses by 1890. It was established at a natural narrowing of the valley, which allowed pioneers to place logs across the river to form a bridge. The site was one of the few Native American fords across the river. This photograph was taken around 1900.

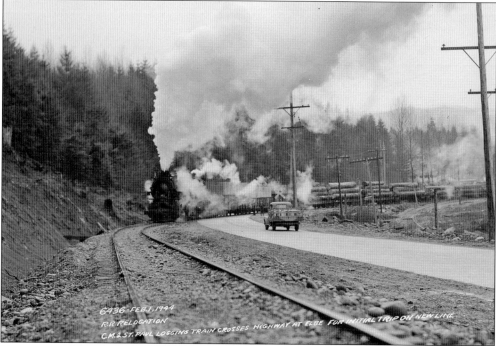

To accommodate the new Alder Lake Reservoir, the railroad tracks from Eatonville to Elbe had to be relocated. The old route followed the Nisqually River from La Grande. The new route came over the Elbe Hills following the Busy Wild Creek and then paralleled the new highway on the uphill side. It took several years to complete the project, but on February 1, 1944, the first train left Elbe on the new tracks. (Courtesy of Tacoma Public Utilities.)

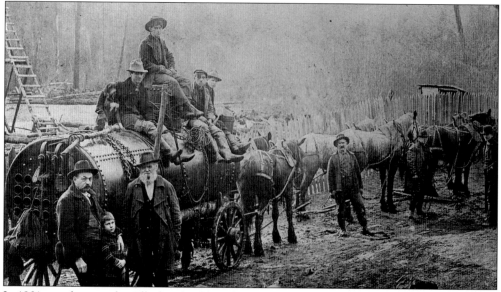

In 1901, people arrived in Elbe by a buckboard stage operated by Jess Cronkhite. The heavy stages were built and maintained by blacksmith and mechanic Levi E. Engel. The first Rainier-bound customer Engel served was Pres. William Howard Taft, who fueled up at Engel's establishment. In 1915, Engel opened the first garage on the highway.

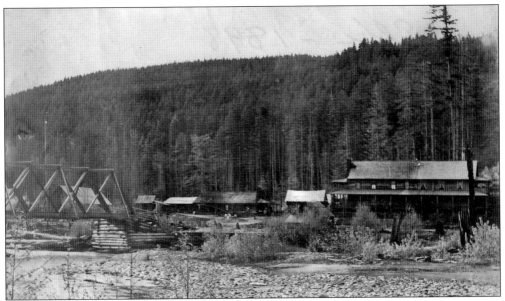

Henry and Charles Lutkens built two tourist hotels in Elbe. The first burned sometime around 1984. The second, built in 1894, was of log and timber construction, with gables and a large veranda facing the scenic braids of the glacial Nisqually River. This is a photograph of the first hotel. (Courtesy of Linda Herrin.)

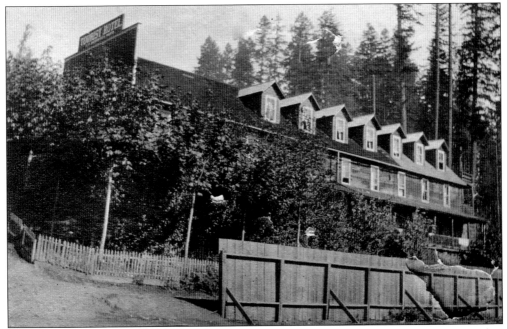

Unlike most of the hotels in the area that served single workers, the "Tourist Hotel" catered to travelers on their way to visit the mountain. It had accommodations appropriate for both men and women. The hotel was removed sometime around 1903 to accommodate the approaching railroad. (Courtesy of Linda Herrin.)

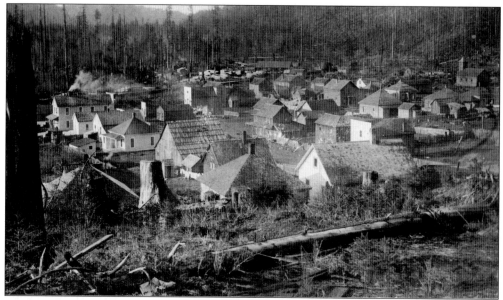

This is the view of 1904 Elbe from the Adam Sachs home, located on a hill to the east of town. One of the hotels can be seen on the left, and the lumber mill is on the far side of the tracks. The road to Eatonville passes close to the edge of the hill in the foreground. (Courtesy of Marie Fore estate.)

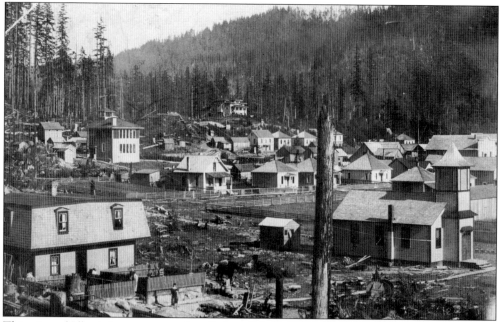

This view of Elbe is from a postcard mailed on July 5, 1908. The Presbyterian church is on the right, the school is on the left, and the Sach home is on the hill in the center of the picture. (Courtesy of Marie Fore estate.)

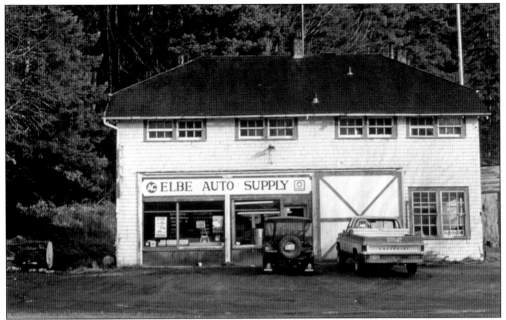

In 1939, the CCC built a "forest protection station" to house crews, shops, and equipment. For many years, the Washington Forest Protection Association representing forest owners had crews stationed here. The crews responded to fires and accidents on privately held forest tracks. In 1971, the building was bought by Gale and Cora Adams from the Department of Transportation. The Adamses established a small auto parts store with a vibrant chain saw sideline. In 2010, it was resold to the Department of Transportation for restoration and use as a traveler's rest. The picture was taken in 1974. (Photograph by Loren Lane.)

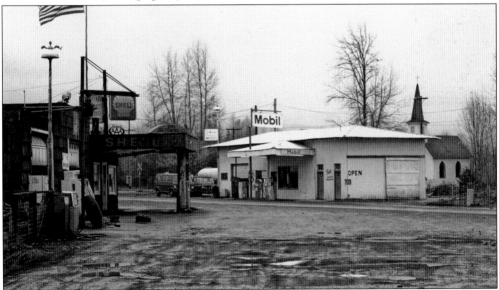

An Elbe visitor in the early 1980s would see that a small diner had been converted by Gale and Cora Adams into a Shell service station that provided tire and towing services. The service station across Highway 7 was operated by Abe Zimmerman. This station burned in 1983. (Photograph by Loren Lane.)

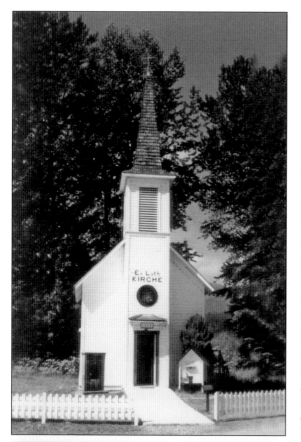

Henry Lutkens donated land to build churches of two different denominations—the German Evangelical Lutheran and the Presbyterian church. Both church buildings were erected in 1906. The Lutheran church has been preserved as a visitor favorite. It is very small, seating fewer than 30 worshipers. Its first pastor was Irvin Oretel, and Carl Kilian of Puyallup, who visited Elbe monthly, followed him. Rev. C. R. McMillian was the first and only resident pastor of the Elbe Presbyterian Church. His successor was Reverend Willart, who was based in Mineral. The Lutheran church is now on the National Register of Historic Places. (At left, courtesy Elbe Lutheran Church; below, photograph by Loren Lane.)

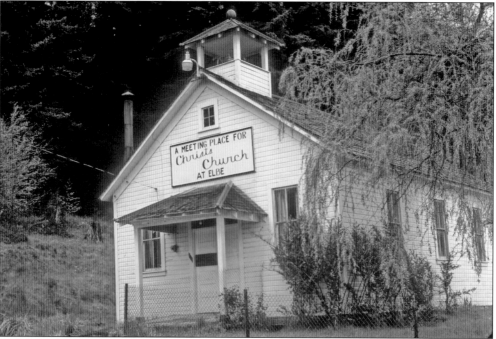

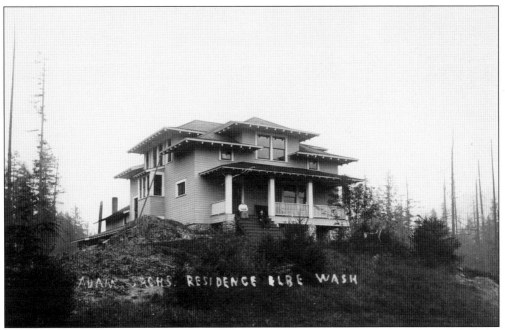

The Adam Sach house was built in 1903 on a bluff to the east of town. Sach was one of the early pioneers in Elbe and had numerous commercial enterprises. His mercantile store was near the current site of the Elbe Tavern. The limited records indicate he maintained the bridge across the Nisqually River and sometimes collected tolls for its use. In 1902, a boiler he ordered arrived and was installed at his Elbe Lumber Company. (Courtesy of Marie Fore estate.)

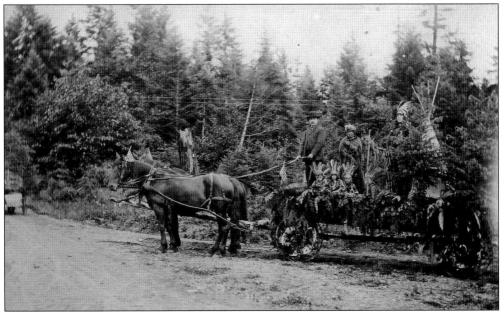

These "wild Indians," as the writing on the back of the photograph identifies them, are dressed in war paint and feathers. It appears that they, and their float, are participating in a community parade. Teepees were not customary housing for the local tribes. William Bewer was the driver of the wagon, Mrs. Ingersol was the tall Indian chief, and Mrs. Canty is the short Indian squaw.

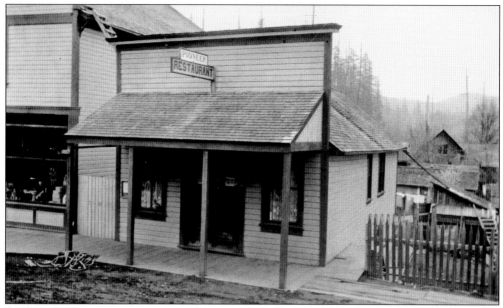

In 1912, the Pioneer Restaurant in Elbe was a busy place, serving tourists, travelers, and locals. Most of the loggers and mill workers lived in company housing and had room and board deducted from their pay. There were people passing through, having a daily hot meal, celebrating, or just wanting a break from the company dining room. (Courtesy of Marie Fore estate.)

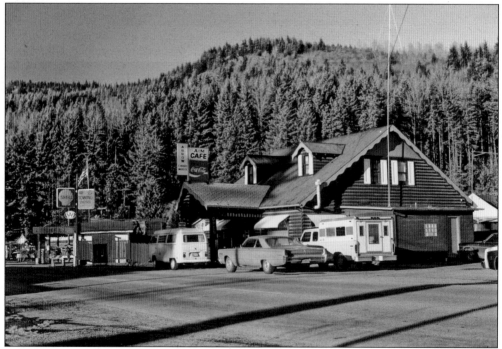

This street view of Elbe in 1977 shows the A&M Café and the Arrow Court Motel in Elbe. The current post office location is just to the right, and to the left is the site of Gayle and Cora Adam's Elbe Shell and Towing. Fire destroyed the A&M building on March 17, 1986. (Photograph by Loren Lane.)

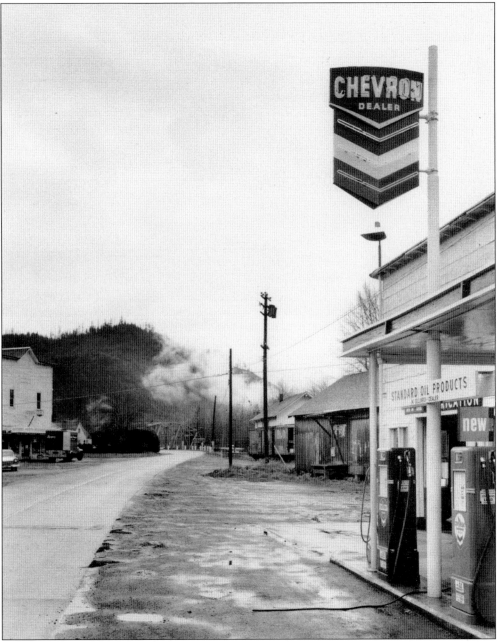

Smoke drifts from a chimney toward the looming hills in Elbe on a rainy February day. The streets appear quiet with no visible traffic proceeding on the two-lane road. There are no cars outside the Chevron pumps at M. Gilliardi's Standard Oil station. A grocery store is farther down the road across from a B&O boxcar. Elbe is a small community on the Nisqually River at the east end of Lake Alder in the south central section of Pierce County. (Courtesy of Tacoma Public Library.)

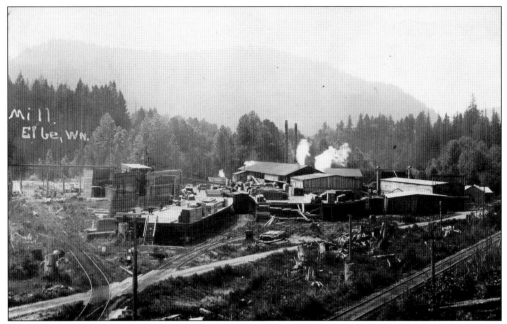

Early in the 20th century, Elbe had two mills, both owned by Adam Sach. The lumber mill was to the south of the railroad tracks, where the parking for the Mount Rainier Scenic Railroad is now found. Lumber mills used primarily fir and hemlock, and shingle and shake mills used cedar exclusively. (Courtesy of Marie Fore estate.)

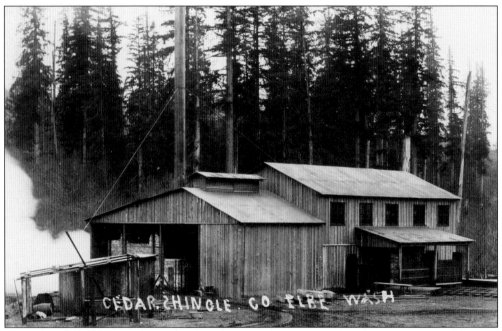

The cedar shingle mill utilized the abundant cedar timber found in Pleasant Valley and other bottomlands. The shake and shingles were the primary roofing material for the growing cities and towns of the west. (Courtesy of Marie Fore estate.)

The Elbe Odd Fellows Hall started life several hundred feet from where it now stands. The early road in Elbe came down the hill and followed a course closer to the hill. Soon after the railroad arrived in 1904, a swampy area to the north of the tracks was filled, and homes and buildings were constructed along the new road. The IOOF Hall, which became the Elbe Grocery, was moved to face the new highway. (Courtesy of Shelly Smith.)

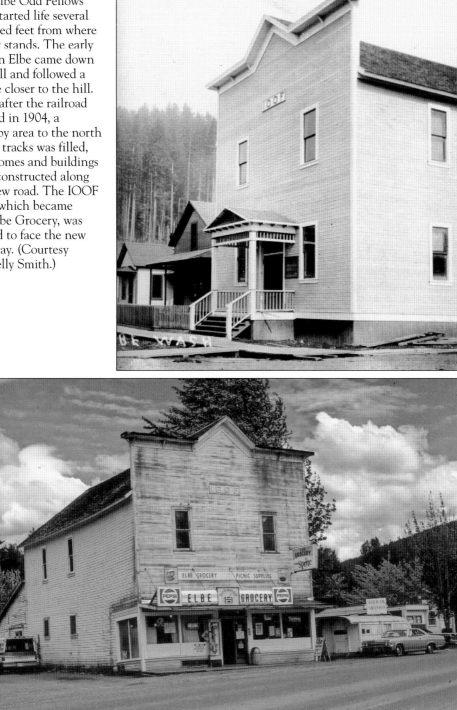

The Elbe Grocery looked a little tired in November 1977. Shelly Smith is now the proprietor. (Photograph by Loren Lane.)

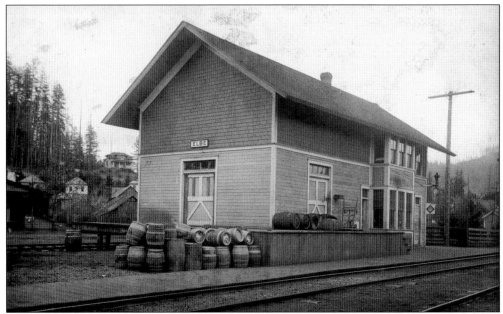

The original Elbe depot is seen here on September 25, 1911. Beer kegs are ready for shipment. The siding track is on the far side of the depot, and the through track is in the foreground. The Sach house can be seen on the hill in the background. The depot for the Mount Rainier Scenic Railroad now occupies this site. The Mount Rainier Scenic Railroad runs rebuilt steam engines to take visitors on a scenic tour of the Nisqually Valley and Mineral. (Courtesy of Marie Fore estate.)

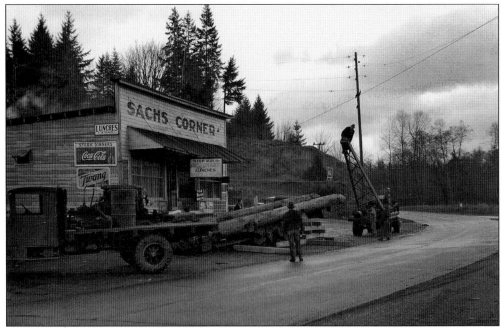

A crew is working to right a logging donkey that has overturned at Sachs Corner on December 2, 1942. Sachs Corner is now the location of the Elbe Bar and Grill. The road to Ashford and the National Park curves to the left. The bridge and the road to Mineral are on the very right of the picture. (Hwy 706, milepost 0.0.) (Courtesy of Tacoma Public Utilities.)

There have been many bridges across the Nisqually River at Elbe. Here is an engineered wooden truss bridge used around 1912. The road across the river would take the traveler to Mineral, Morton, and the Cowlitz Valley. Levi Engel's blacksmith and auto repair shop is in the lower right.

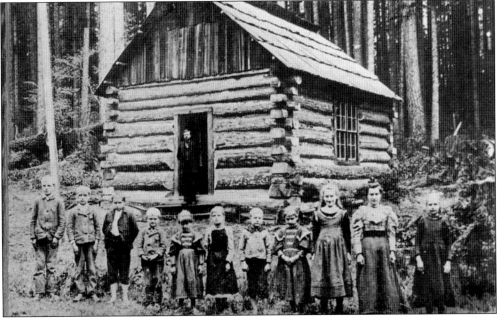

The first Elbe school was established in 1891 in a 10-by-12-foot log cabin. Here is the second school, built a few years later, and it is a little larger. Both schools were located near the current bridge. (Courtesy of Linda Herrin.)

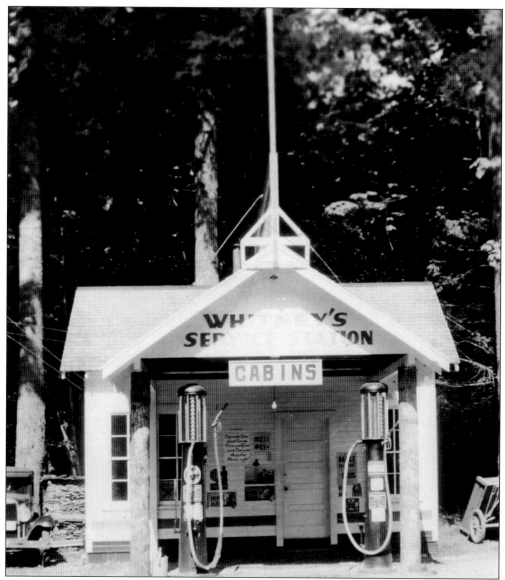

Whitney's Park had cabins, a picnic area, a little store, and gas. It was located on the Lewis County side of the Nisqually River, across the bridge and to the right. The storefront still remains. (Courtesy of Marie Fore estate.)

Six

PARK JUNCTION, NATIONAL, ASHFORD, AND SUCCOTASH VALLEY

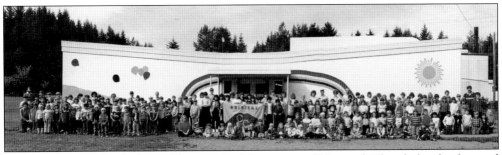

Columbia Crest School is located between Park Junction and National. The whole school turned out in 1982 to admire the new artwork on the building and to have their picture taken. At this time, the school served students from kindergarten through the eighth grade and from the communities of Alder to Longmire. (Courtesy Columbia Crest School.)

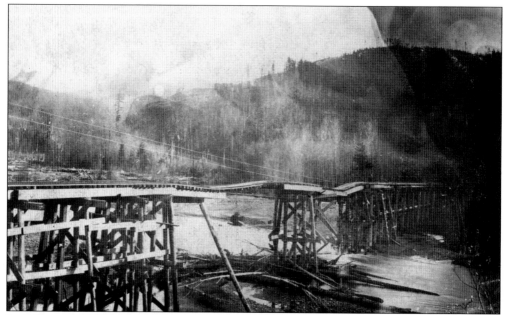

In 1917, many of the bridges that crossed the Nisqually River were built on pilings. When the river flooded, logs that were loose on the gravel bars would float free and then smash into the bridge pilings and abutments. In other cases, these logs would get stuck in the pilings and form crude dams. Either way, the bridges were weakened and frequently collapsed. (Hwy 706, milepost 2.40.) (Courtesy of Ollie Calvin estate.)

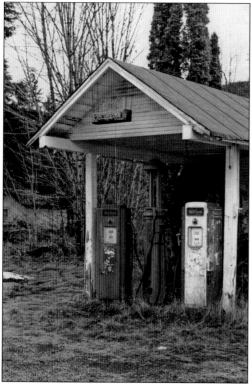

The Auvil family owned this filling station in Park Junction. There were several tourist cabins behind the station. (Hwy 706, milepost 3.) (Photograph by Loren Lane.)

Tahoma Woods is the site of the administrative headquarters of Mount Rainier National Park. In a national program titled "Mission '66," the National Park Service sought congressional support to update deferred maintenance and construction in the national park. Planning for the relocation of administrative and support facilities started in 1946. On the campus are the headquarters building, housing units, greenhouses, and educational facilities. (Courtesy of National Park Service.)

Development work started in the late 1960s, and occupancy in the early 1970s. Housing units such as these are now only used for seasonal and transferring employees. The process of relocating support facilities from within to the park to Tahoma Woods continues as funding becomes available. (Courtesy of National Park Service.)

Park Junction was the location on the Tacoma Eastern where a spur continued east up the valley to National and Ashford. The main line turned south, crossed the valley, then the river, and then went on to Mineral and Morton. In later years, the Ceccanti family had a ranch that bordered

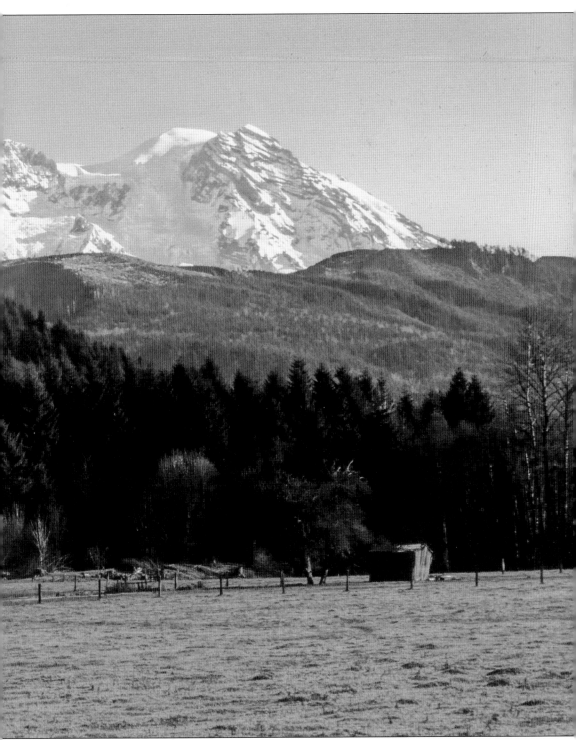

on the two tracks. With Mount Rainier rising over the fields and tree-covered hills, this has long been a favorite photograph stop. (Hwy 706, milepost 2.4.) (Photograph by Loren Lane.)

Columbia Crest is the elementary school serving the Upper Nisqually Valley. It is part of Eatonville School District No. 214. It was built in 1950 to serve students from Alder, Elbe, Ashford, and Longmire. (Hwy 706, milepost 4.) (Courtesy of Tacoma Public Library.)

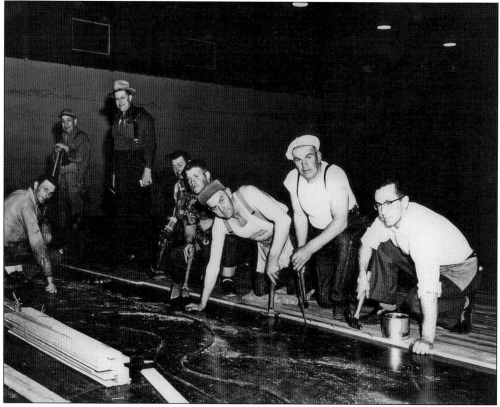

One of the strengths of Columbia Crest has been the strong support it has received over the years from the community. Members of the Mount Rainier Lions are laying the floor of the new gymnasium. Over the years, the Lions have provided playground equipment and funding for field trips and assemblies. The members of the Grange have provided tutors, mentors, and material assistance for needy students. (Courtesy of Marie Fore estate.)

Walter A. Ashford is taking a buggy ride to Elbe from his home in Ashford. The road conditions were normal for 1905. Any amount of rain could turn the road into a quagmire. Ashford advocated for improving the road to reduce the travel time from the depot in Ashford to Longmire Springs. (Hwy 706, milepost 4.5.) (Courtesy of Columbia Crest School.)

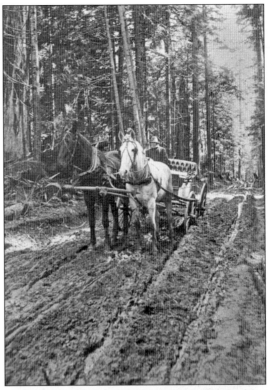

In 1908, Ted Borden of Ashford served as a county road superintendent. Here he is leading a crew and using his horses to pull a scraper to level the roadbed near Park Junction. Ted is the one on the right without a hat. Note how thick the trees are and how the road seems to wind its way around them. (Hwy 706, milepost 1.) (Courtesy of Marie Fore estate.)

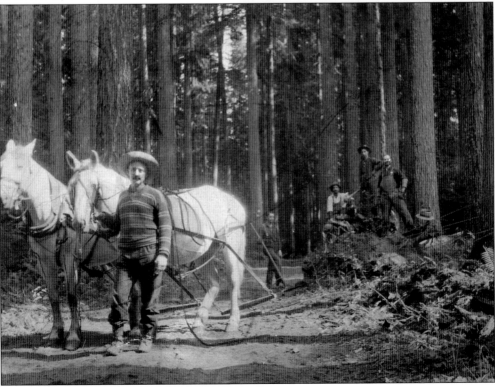

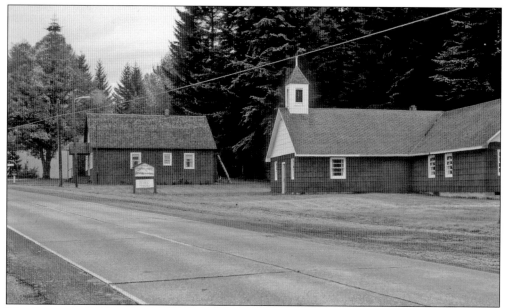

The Community Church served the residents of National and Ashford. Built around 1913 by community members, the church served as a meetinghouse for a number of religious leaders. Records show that the Free Methodists, Roman Catholics, Baptists, Methodists, and any number of evangelists used the building at one time or another. (Hwy 706, milepost 6.5.) (Photograph by Loren Lane.)

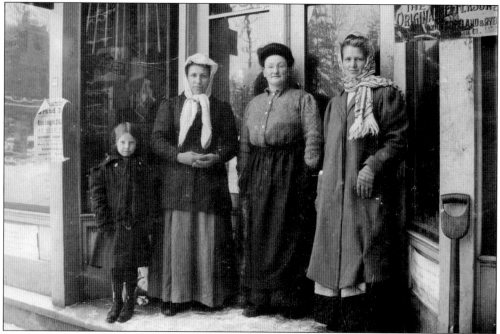

Butler's Store in National carried a variety of general merchandise. Pictured from left to right are little Elgie Borden, Anna Borden, Estelle Butler, and Inez Borden. The flyer in the window is announcing a band that will be playing at the Alder IOOF hall. (Hwy 706, milepost 6.3.) (Courtesy of Marie Fore estate.)

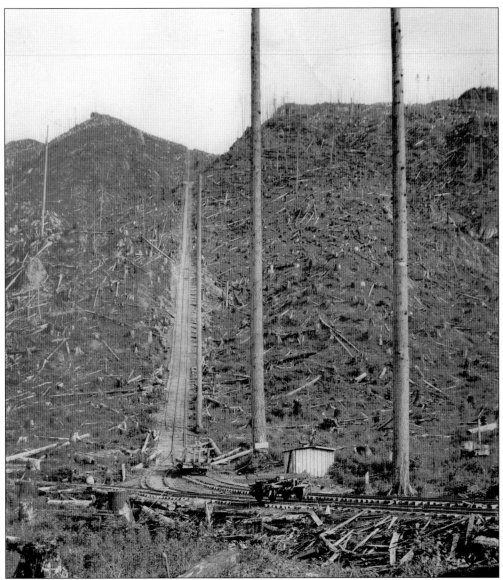

One of the unusual features of the National operations was the incline located across the river from the mill. An incline was a rail line that went up and over a hill rather than through or around. On the far side of the hill was a steam donkey that would pull cars up or ease them down. This system could be duplicated to allow the trains to reach deeper into the woods and operate at greater elevations. In the late 1930s, a crew car was being lowered from the top when the cable broke, some of the crew were able to jump off, but 12 workers were killed. (Courtesy of Rick Johnson and Ashford Creek Pottery.)

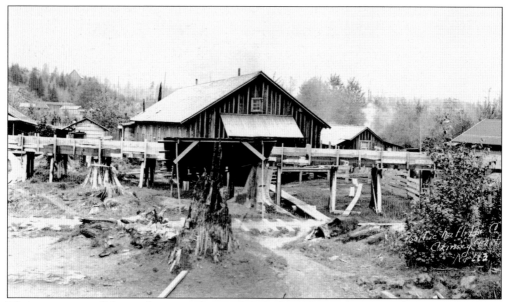

The community of National organized around 1910 when the Pacific National Lumber Company moved its operation from Pacific County to near Ashford. In that year, the Butler store and the post office opened. This early mill in National used a flume system to move logs from the millpond to the sawmill. On May 13, 1912, a fire from one of the mills was fanned by strong winds. The resulting fire destroyed two mills, nearly 20 homes, the National General Store, and at least eight Tacoma Eastern flatcars. One and a half million shakes ready for shipping were also destroyed in the fire. The Elbe Ashford area did not have fire district coverage until 1968. (Courtesy of Rick Johnson and Ashford Creek Pottery.)

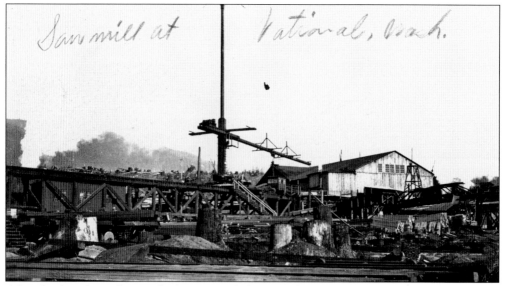

After the fire, the mill was rebuilt on a much larger scale. For a number of years, it was one of the largest mills in the world, based on the number of board feet produced in a month. One of the efficiencies of the mill was the spar crane. It was able to move loads between the various operations of the mill. The head rig at National was able to cut very large logs over 120 feet in length. (Courtesy of Marie Fore estate.)

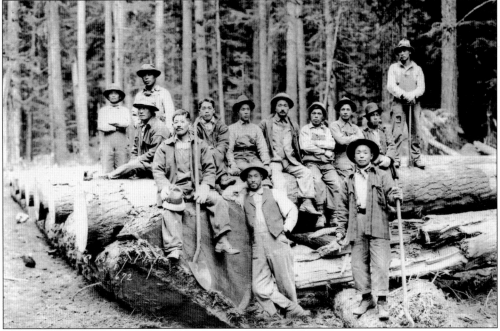

The National mill and many other operations in the valley employed a number of Issei (born in Japan) and Nisei (Japanese born in the United States and holding American citizenship) and Sansei (the sons or daughters of Nisei). Some worked in the mills, but most worked laying track and building bridges. At the outbreak of World War II, they and their families were relocated to internment camps in eastern areas of California, Oregon, southern Idaho, and other sites in the Mountain West. (Courtesy of Rick Johnson and Ashford Creek Pottery.)

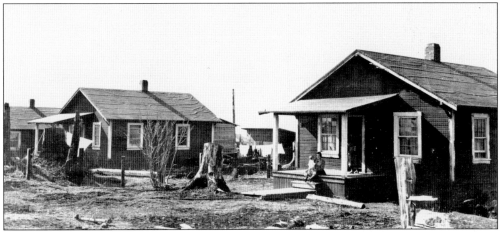

The mill houses from National were sold when Weyerhaeuser Company decided to completely clear the old town site. Single bedroom houses sold for $100, two bedrooms for $200, three bedrooms for $300, and so on. One condition was that all of the houses had to be removed within 30 days. Thus started the great "National House Movement." After work each day, teams of the new owners lifted the houses off their foundations, placed them on trailers or skids, then hauled them to the new site, where they were then lifted onto the newly prepared foundation. Today as one travels from Elbe to the Park Gate they can see these houses. The Grange building in Elbe and the Whittier Bunkhouse are from National, as are over 20 other homes in the valley.

The Succotash Valley, or what is now known as Ashford, was settled as early as 1887 when the Allen family started their homestead. Walter Ashford and Bill Osborn soon followed them in 1888. The post office was established on November 16, 1894, and a school was established in 1900. The Tacoma Eastern railroad arrived in Ashford in 1904. (Hwy 706, milepost 7.1.) (Photograph by Loren Lane.)

The Mountain Diner was the home of the "Mountain Burger" and was a longtime landmark in Ashford. Owned by Winnie "Flo" Wells, it was noted for quality food and meticulous attention to each order. Service was not fast, but the persistence of the business is a tribute to the popularity of the food. (Hwy 706, milepost 7.2.) (Courtesy of Laurie Anderson.)

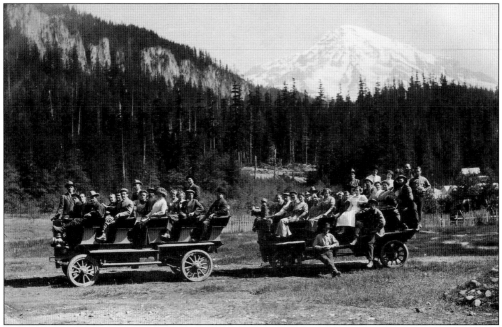

By 1915, motor coaches like these had replaced the horse-drawn stages used to transport tourists from the railroad in Ashford to Longmire Springs. In June 1916, the road from the Nisqually Glacier to Paradise Valley was completed. (Hwy 706, milepost 7.6.)

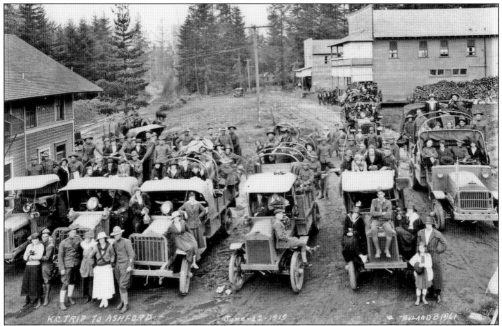

On June 22, 1919, approximately 125 convalescents from the Camp Lewis hospital, along with 125 girls from Tacoma, journeyed in army trucks as far up Mount Tacoma (Rainier) as possible, stopping to have their photograph taken in Ashford. Picnic lunches were provided and various activities such as tobogganing and snowballing were scheduled. The Tacoma chapters of the Knights of Columbus organized the trip. (Hwy 706, milepost 7.6.) (Courtesy of Tacoma Public Library.)

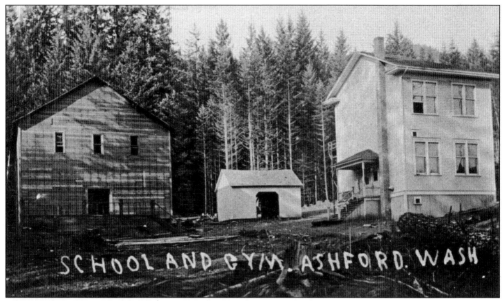

The school pictured here was constructed sometime between 1903 and 1912. It is a two-room school with an expansion built in. The state paid for the classrooms, but the community provided the gymnasium and the wood play shed in the center of the picture. (Hwy 706, milepost 7.7.) (Courtesy of Rick Johnson and Ashford Creek Pottery.)

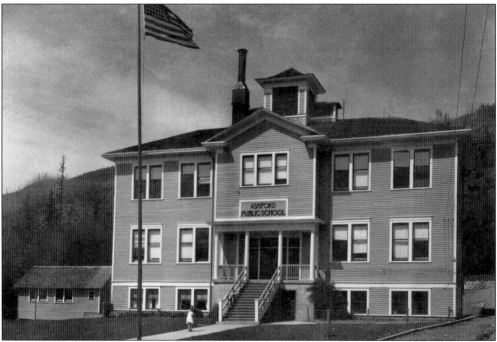

After 1912, the community and the school both expanded. The rebuilt mill in National offered employment to many new families. The school was expanded by adding an additional two classrooms, the entryway, and stairs. The basement was used as a lunchroom and indoor play area. This building served the community until it burned in 1949. (Hwy 706, milepost 7.7.) (Courtesy of Rick Johnson and Ashford Creek Pottery.)

The school fire burned the upper stories of the building. The basement was bought by a local businessman and turned into what is now the Highland Restaurant. The restaurant still bears some scars of the fire and boasts a collection of historic photographs of the community. (Courtesy of Laurie Anderson.)

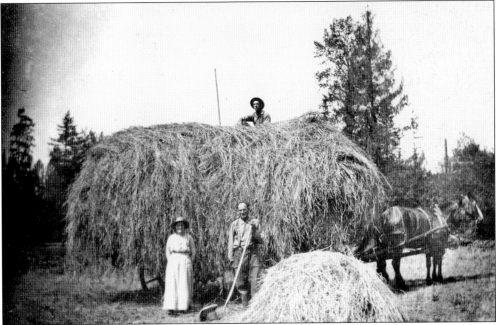

The Borden family had their homestead south of the highway near the river. Here Anna and Ted are bringing in hay for their horses. They had several teams and hauled freight. In the summer, they worked for the Reese family at their Camp of the Clouds, a seasonal tent camp located at Alta Vista above the Paradise Valley, at the 7,000-foot level on Mount Rainier. (Hwy 706, milepost 7.7.) (Courtesy of Marie Fore estate.)

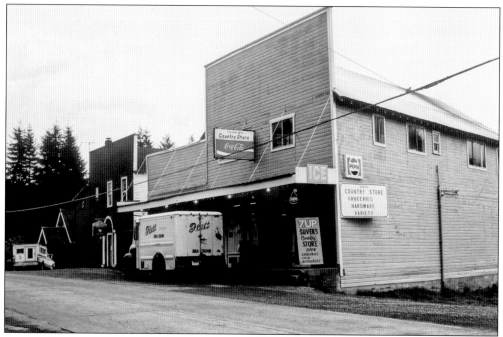

Suver's store was one of the very early buildings in Ashford. This photograph from the fall of 1978 has the dairy truck making its deliveries. The general mercantile store provided food, clothing, snacks, souvenirs, post office, and plumbing and electrical items for the home repair. (Hwy 706, milepost 7.8.) (Photograph by Loren Lane.)

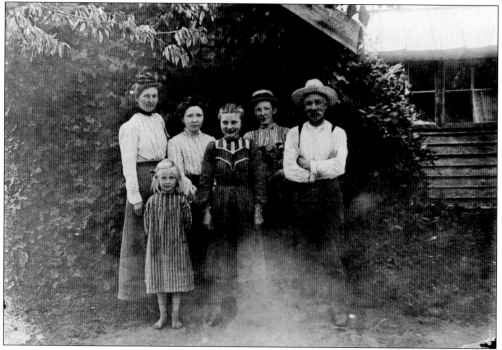

The Ashford family gathers in the garden for this photograph. Pictured from left to right are Cora Hershey Ashford, Zinah, Emma, John, Walter Ashford, and younger daughter Mildred in front.

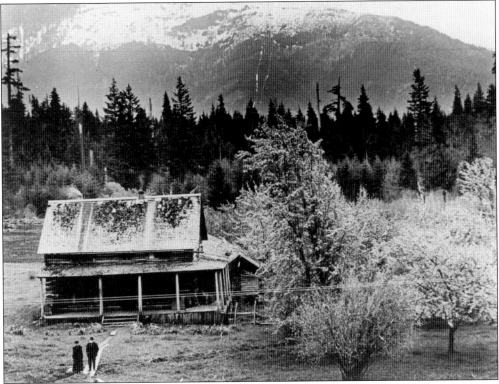

The Peter Hershey homestead, seen here in 1924, was located off the old Mount Tahoma Canyon Road. Osborn Mountain is seen in the background. For many years, it was the oldest building in the area, constructed in the 1890s. Peter Hershey was the brother of the chocolatier and philanthropist from Pennsylvania. (Mount Tahoma Canyon Road, milepost 2.) (Courtesy of Rick Johnson and Ashford Creek Pottery.)

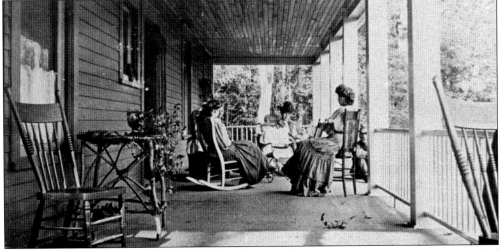

The ladies gather on the porch to greet visitors. The Tacoma Eastern Railroad arrived in Ashford in July 1904. The round-trip fare from Tacoma to Paradise was $6 and included a motor coach trip from Ashford to Paradise. The train left Tacoma at 9:00 a.m. and arrived in Ashford at noon. (Mount Tahoma County Road, milepost 2.) (Courtesy of Rick Johnson and Ashford Creek Pottery.)

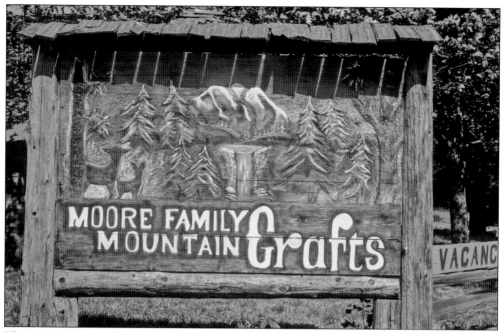

The Moore Family Mountain Crafts was a popular collection of craft artisans who worked beside the road to Rainier between 1976 and 1990. There were potters, candle makers, blacksmiths, glassblowers, oil painters, woodcarvers, and stained glass workers. Eleven toy makers were employed in the off-season to keep up with demand for the handcrafted toys. Each craftsman had their own space, and visitors could watch the work in progress. (Hwy 706, milepost 8.8.) (Photograph by Loren Lane.)

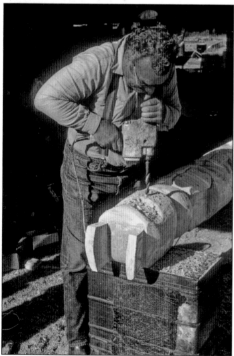

Dwayne "Duke" Moore was the master wood-carver. Here in 1978, he is working on a totem pole. One of his passions was the carving of carousel animals. His carvings are still highly prized in the area. (Photograph by Loren Lane.)

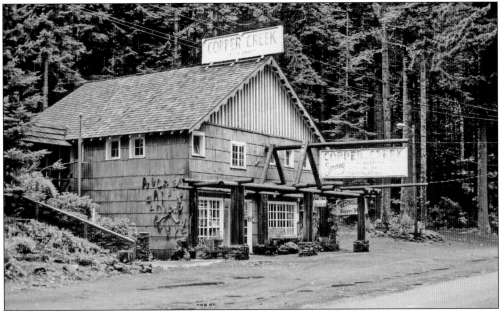

The Copper Creek Restaurant has been a popular eatery since Roselea Triggs converted it from a service station in 1946. They serve blackberry pie and stay open year-round to feed both visitors and residents. The restaurant is located near the spectacular Copper Creek Bridge. (Hwy 706, milepost 11.2.) (Photograph by Loren Lane.)

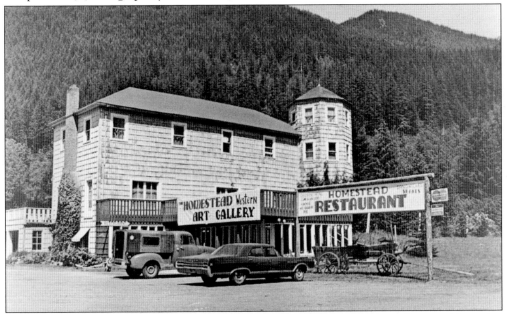

Alexander's is a restaurant and bed-and-breakfast located on the road to Mount Rainier. Alexander Mesler Jr. built it in 1912 as a roadhouse. In 1940, Harry Pappajohn, head chef at the Paradise Inn, bought the property for $2,000 and back taxes. He married and his wife, Mabel, ran Alexander's while Harry continued his seasonal work at the Paradise Inn. In the early 1970s, guests could select the trout from a trout pool and have them prepared fresh. (Hwy 706, milepost 12.3.) (Photograph by Loren Lane.)

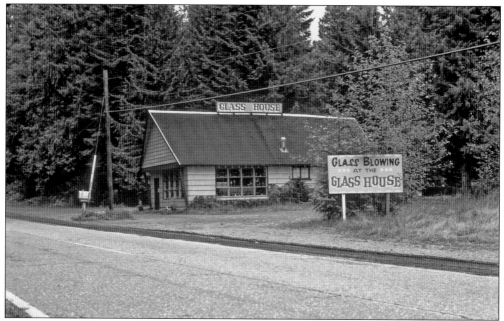

The Glass House offered the visitors a variety of glasswork, both blown glass and flame work. In the late 1970s, Pat Ward was the proprietor, and her Christmas ornaments were a favorite of visitors and locals. (Hwy 706, milepost 12.7.) (Photograph by Loren Lane.)

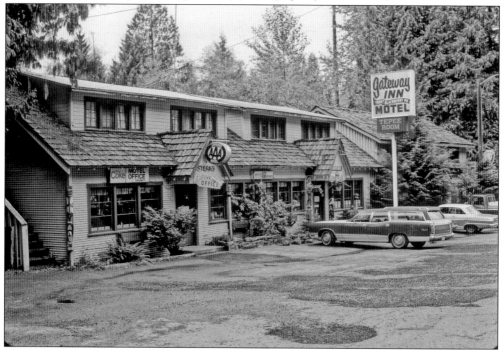

The Gateway Inn is located just outside the park boundary. Built by Hollis Burrnet, it had the "Teepee dining room," gift shop, and rooms and cabins. It is the very first restaurant returning mountain climbers can stop at outside of the park gates. (Hwy 706, milepost 14.5.) (Photograph by Loren Lane.)

Seven

FLYNN, MINERAL, LADD, AND PLEASANT VALLEY

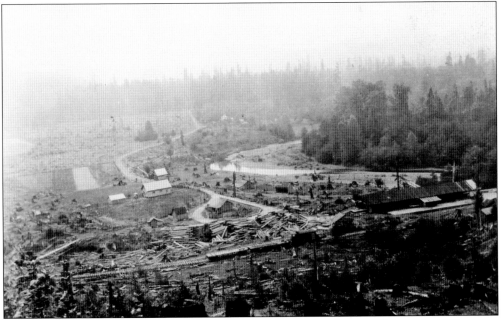

From Park Junction, taking the railroad spur south led to the small town of Flynn. In 1889, a store was established to serve the new families who were homesteading in the area. A small school in Flynn was opened in 1908, and several more families arrived in 1910. (Courtesy of Jim Hale.)

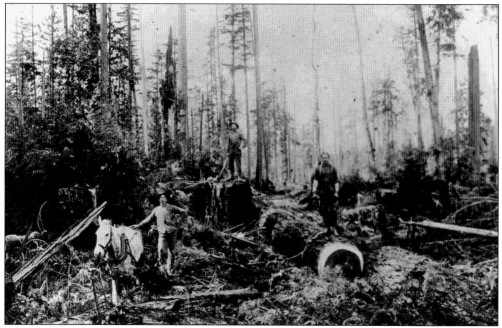

Before the railroad arrived in 1904, the land of the Nisqually Valley had to be cleared by heavy labor and draft animals. This early photograph taken from around Flynn shows the process. The trees were taken down by saw and ax. Then the limbs and branches were removed and the butt or large end was "snipped" or beveled so that it would not dig into the road. The logs were hauled out for lumber or other uses. The limbs, branches, and tops were burned. The stumps were removed by pulling them out with teams, blowing them up with powder, burning them, or quite possibly all of the above. (Courtesy of Jim Hale.)

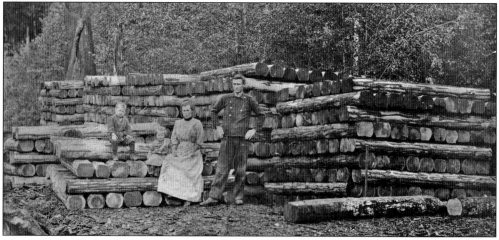

Homesteaders had to find ways to earn cash while they were "prooving up" their property. One common method in the valley was to make railroad ties from the timber cleared from the fields. The railroads needed some 5,000 ties (wooden cross pieces used to hold the rails) per mile of track. The ties had to be 8 feet long, 8 inches wide, and 8 inches tall. The ties had to be flat on two sides, within 8 feet of the railroad right-of-way, and in lots of at least 1,000 ties to make a sale. Here J. D. "Gee" Hale poses in 1910 with his wife and child by the family's tie pile near Flynn. (Courtesy of Jim Hale.)

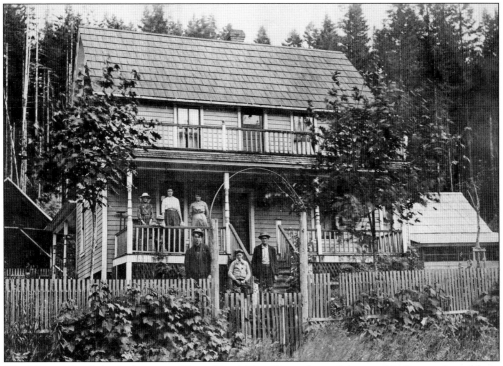

The Meyers family had a house on Flynn Road. The Kentucky architectural influence is visible in the front porch and back veranda. This site is where the current Hale property is now. (Courtesy of Jim Hale.)

On Flynn Road, in the yard of the old Flynn school, Mr. Stillian kept bees. The honey was sold to the local stores, who in turn distributed it to hotels and boardinghouses. In the background is the boys' "necessary," which was in the opposite corner of the schoolyard from the girls' facility. (Courtesy of Jim Hale.)

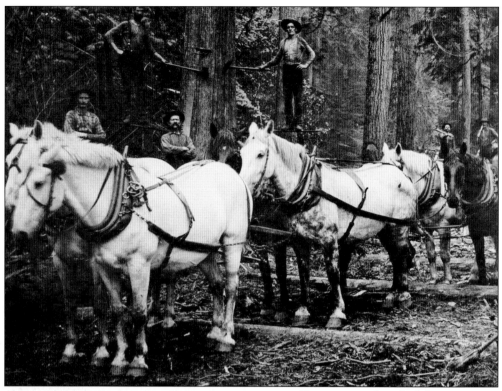

Here a team of six draft horses are being used to drag a log along a "skid road." One can see the skids that have been laid perpendicular to the direction of the road. This reduced the amount of drag generated by the log, insured that the horses had good footing, and protected the road from rutting. Taking a buggy or wagon on the road when the skids were in was bumpy. (Courtesy of Jim Hale.)

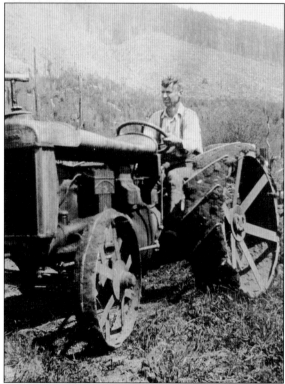

This picture of J. D. Hale was taken in the 1920s with McFadden hill in background. He was using a Ford Model F tractor. (Courtesy of Jim Hale.)

Mineral Lake is a glacier-formed lake. It is unusually deep for its surface area. It is now a fishing lake stocked by the Department of Fish and Wildlife, but historically it was a working lake that served the loggers of the area. There are many logs at the bottom of the lake, and the Model T that accidentally sank after racing on the ice has been recovered. (Courtesy of Jim Hale.)

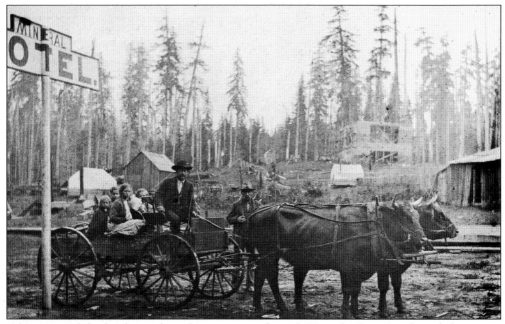

After some of the land was cleared, crops were planted. Here the Fritz family and their oxen have come to town. Their homestead was west of town where the Ladd railroad spur crossed the Morton/Elbe Road. The oxen were well known in the community. They helped many of the early homesteaders remove the stumps from their home and building sites. In snowy weather, the sons of the family used the oxen to transport the schoolchildren from what would become Ladd and Carlson. We can date this photograph to 1905 because of the school under construction in the background. (Courtesy of Nancy Wing.)

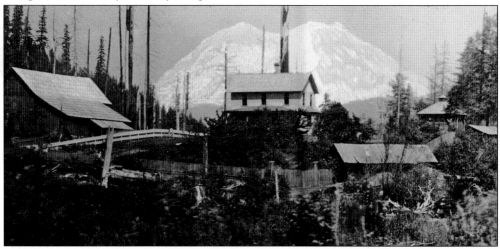

The Bolinger homestead was west of town, near where the current Highway 7 and Mineral North Road meet. Joseph Bolinger first settled in Mineral in 1889. Like many of the other early settlers, this pioneer family had a number of projects underway. After the land was cleared, they had some milk cows, hogs, and beef cattle. They tried growing hops, but soon found that onions were a better crop for the weather and soil. Some years they dried over 3 tons of onions in their large barn. Some of the onions were sold to stores and wholesalers, and others were used as hog feed. (Courtesy of Jim Hale.)

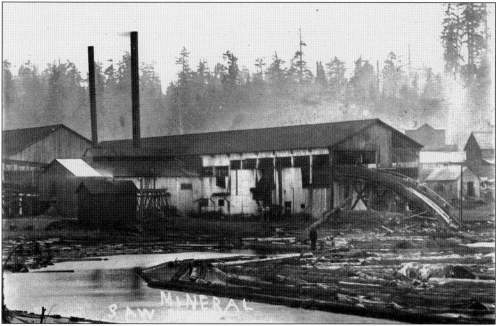

The first major mill on Mineral Lake was Mineral Lake Lumber, built in 1905 by John Donahue. Other mills, mines, and business soon turned Mineral into a little boomtown. The Donahue mill burned in 1922 and was not rebuilt. (Courtesy of Jim Hale.)

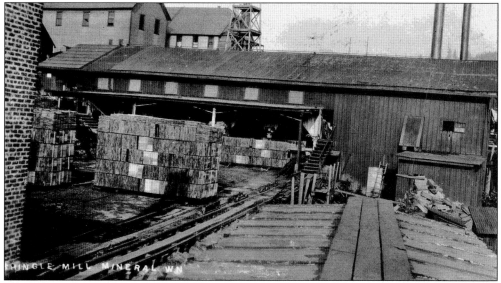

The M. R. Smith Shingle Company mill was established in 1905 and survived into the 1980s. Western cedar grows as single trees or in small groves. The mill paid a small premium for cedar logs, cut them into bolts of generally 16 inches for shakes and 24 inches for shingles. The bolts were then debarked and graded. Shakes could be made by hand, and when milled were smooth on one side and had a uniform thickness. Shingles were cut to a taper from three-eighth inches to a point. Shakes and shingles that were to be transported were kiln dried to reduce shipping weight. A properly installed cedar roof could last over 60 years. The terminology for shakes and shingles appears to have varied by time and location. (Courtesy of Jim Hale.)

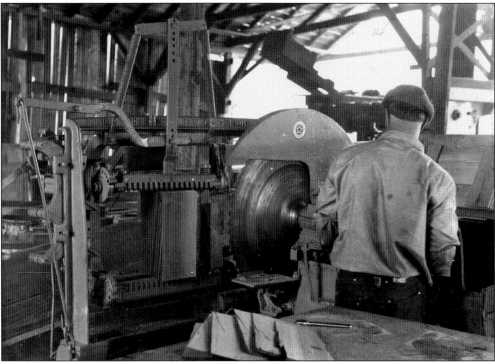

A weaver stands by the saw used to cut shingles. The shake blank was at least 3 inches wide and 16 inches long and was then cut on the bias to form two sloped pieces. The Shingle/Shake Weavers Guild in Mineral was organized with the assistance of the store owner, Ralph "R. C." Wheeler. (Courtesy of University of Washington Pack Forest.)

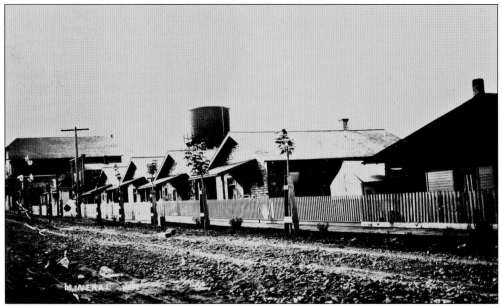

These four houses were built for married mill workers with children. The Mineral Lake Hotel can be seen on the corner. The houses had running water and were close to the mill, the school, and shopping. The houses were still being rented out in the early 1970s. (Courtesy of Jim Hale.)

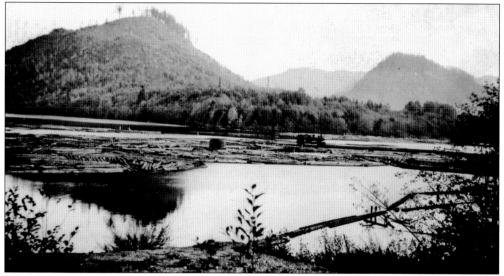

The decades between 1900 and 1920 saw major shifts in logging technologies. Draft animals were out, and steam was in. Small steam boilers were matched with strong cable drums. These new units were called donkeys and moved logging from small family activities to large corporations. Steam allowed crews to move logs from where they lay to rail tracks over a mile away. The trains could then take them to the mill or market. Small, powerful locomotives were developed that allowed trains to climb steep grades and travel around tight corners. Here is one of these locomotives on a trestle built over Mineral Lake where it has unloaded logs into the lake. (Courtesy of Jim Hale.)

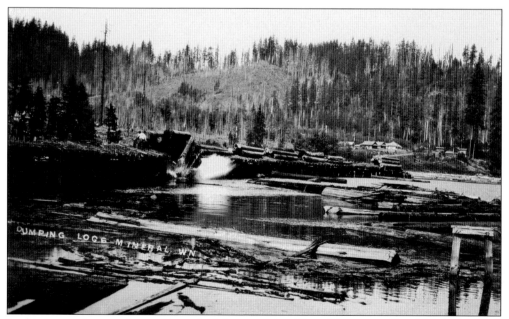

In this image, logs are dumped into the lake to await milling. (Courtesy of Jim Hale.)

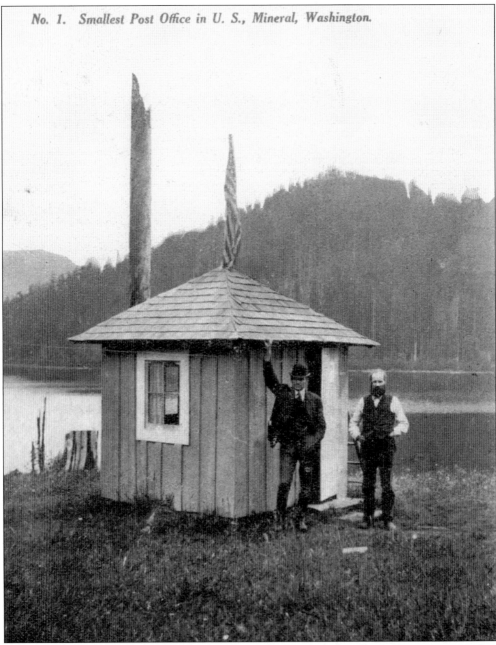

No. 1. Smallest Post Office in U. S., Mineral, Washington.

The establishment of a post office was considered the founding date for the town. It meant that the town would appear on maps, and residents would be able to receive goods as well as letters. This was the era of the Sears and Roebuck and Montgomery Ward catalogs. Mineral's first postmaster, Guemsey G. Hardy, arrived in 1892 and was responsible for bringing the mail from Elbe to Mineral by wagon and horseback. August Ahlstrand built this tiny post office in 1898, and it served the residents of the area for 10 years. Until the railroad arrived, he had to walk to Elbe to get the mail. The mail arrived by train from 1906 to 1926, when the mail switched to a Star route. The building Ahlstrand constructed still stands near the Mineral Lake on the Mineral Hill Road. (Courtesy of Jim Hale.)

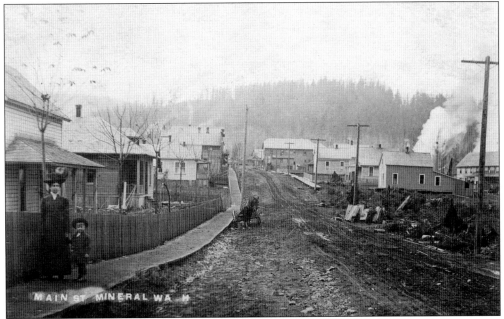

The layout of the town was well established by 1910. Front Street went from the future site of the Hill-Rowe store on the west end to the train depot on the east. The mills were located on the north side of Front Street and extended to the lake. The stores, taverns, cafés, and some hotels and houses were on the south side. The school was on a high point, two blocks south of Front Street. Homes were also built south of Front Street and along the western lakeshore. The early Japanese village was on the southeast corner of the lake. (Courtesy of Jim Hale.)

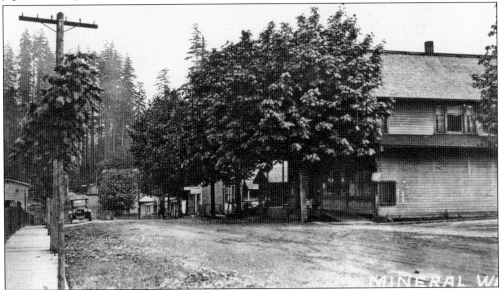

There is a story that an elderly Native American who lived in the area had noted from the movies that all of the great cities of the East had tree-lined streets. He transplanted a number of maple trees along Front Street. About 30 years later, the trees were removed. The summer shade was appreciated, but the leaves and the damage the roots had on the boardwalks prompted their removal. (Courtesy of Jim Hale.)

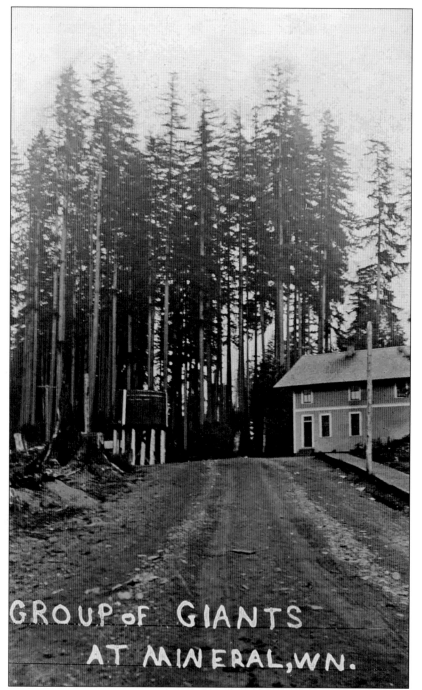

GROUP of GIANTS
AT MINERAL, WN.

The Tacoma Eastern Railroad built the train depot between 1906 and 1907. With its telegraph connections, it controlled train traffic for the mills, mines, and loggers in the area. It took four additional years for the tracks to be laid all the way to Morton. The railroad was an agent for Wells Fargo and delivered freight to the locals. The depot had some fuel storage, a water tank filled by an artesian well, and a tank of sand that the engines used to improve traction on the steeper grades. The Mineral depot was 54 track miles from Tacoma. (Courtesy of Jim Hale.)

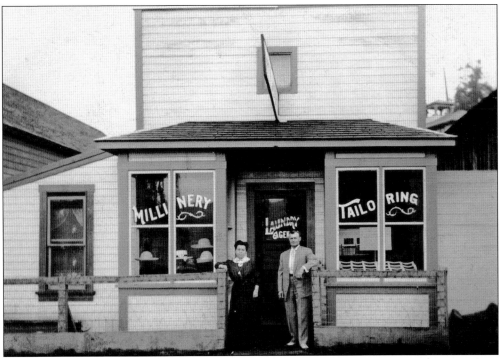

Mineral Lake Lumber had over 200 men working in the mill. There were many more men working in the woods to supply logs for the mills. To keep the loggers and their families supplied, we know that there were three general stores, a millinery (ladies hats), a tailor shop, ice cream parlor, watch sales and repairs, cobbler, barbershop, three taverns, blacksmith and auto garage, and a medical clinic along Front Street. (Courtesy of Jim Hale.)

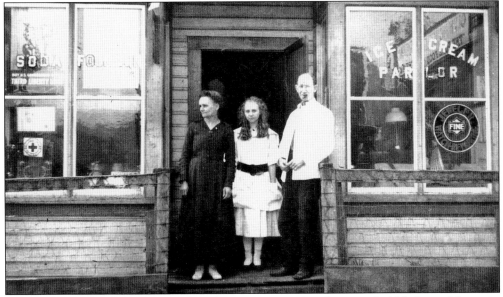

Ice cream was probably made locally. The ice cream parlor also served old-fashioned fountain soda. This photograph is part of a series taken by an itinerant photographer who captured each of the businesses on Front Street. (Courtesy of Jim Hale.)

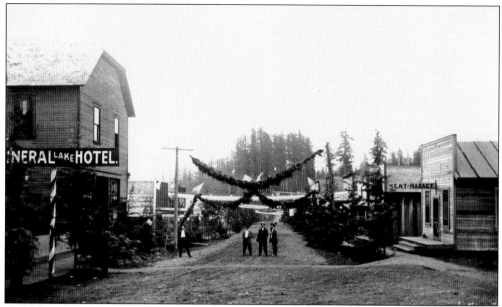

The parade committee checks out Front Street before the Fourth of July celebration in this c. 1908 photograph. (Courtesy of Jim Hale.)

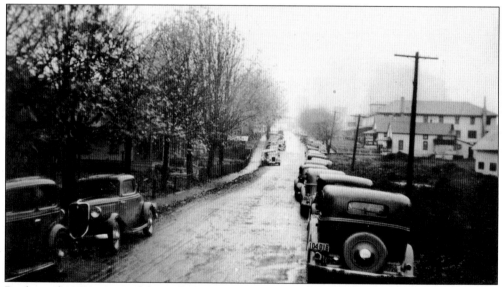

By the mid-1930s, many of the mill workers owned their own cars. This view looking west from near the depot shows that parking was limited. In 1935, the Lumber and Sawmill Workers Union struck for 13 weeks for recognition of the union. Eleven years later, the union would strike again, industry-wide. For nine weeks, no union members produced lumber. The union also organized a strike in 1954 to gain wage concessions and in 1963 for wages, health benefits, and pensions. (Courtesy of Jim Hale.)

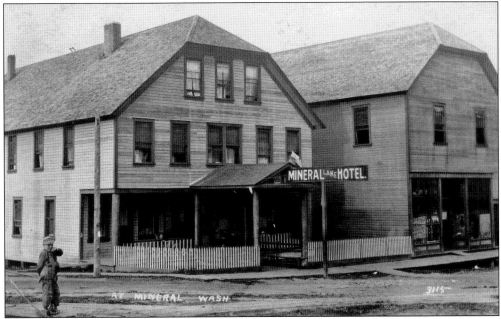

Hotels, bunkhouses, and boardinghouses provided much of Mineral's housing in the early years. The loggers and mill workers who did not have their families with them used them extensively. For a set price, they would get a bed, three meals a day, and maybe a shower and bath. Hoteliers served enormous breakfasts trying to meet the expectations of the newly arrived immigrants from Norway and Sweden wanting their pancakes and the migrants from Kentucky who hungered for their grits. Lunch was prepared by girls in the early morning and consisted of meat sandwiches, fruit, and cookies. Supper was the big meal of the day and was often set to a weekly schedule. It would include plenty of meat, potatoes, greens, vegetables, and dessert. Fish, either canned or fresh caught, was available on Friday nights. (Courtesy of Jim Hale.)

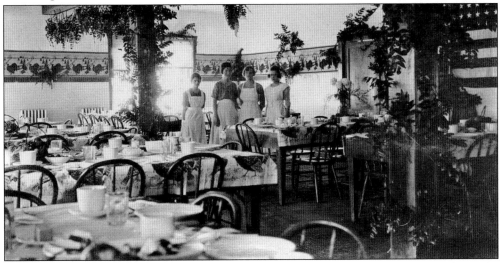

Special occasions were observed in the hotels. This scene from the West Fork Hotel has the serving staff ready and the tables set for Thanksgiving. The decorations on the wall are of turkeys and pilgrims. Each table has its sugar, cream, salt, pepper, honey, and coffee mugs ready to go. (Courtesy of Ollie Calvin estate.)

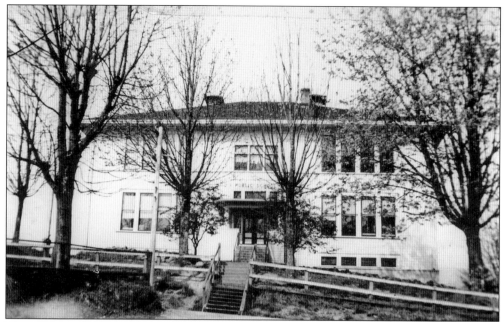

This is the Mineral school. At this point, it had eight classrooms and served students through high school.

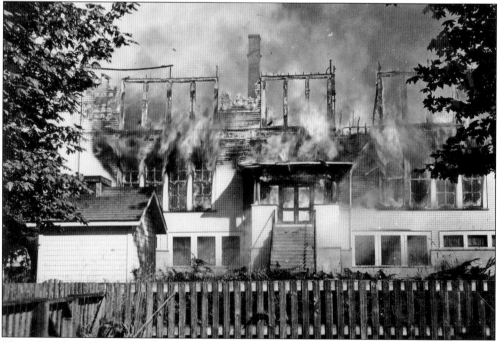

The school burned in September 1945. After the arson, classes were conducted in the gym until it too burned. The students were then bussed to Morton until a new school, which opened in 1947, could be built. (Courtesy of Jean Shields.)

Sundays were the only day of rest each week. The married workers tried to reach their families Saturday night and returned to the work site by Sunday night. For the unmarried, Sunday was sports day. Baseball was a popular activity. Each community had two or three teams. There were local leagues, and teams from Mineral would travel to National, Morton, and maybe as far as Spanaway for a game. Other recreation included fishing, hunting, and going to dances at one of the several dancehalls in the area. (Courtesy of Jim Hale.)

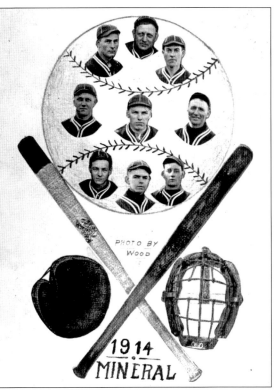

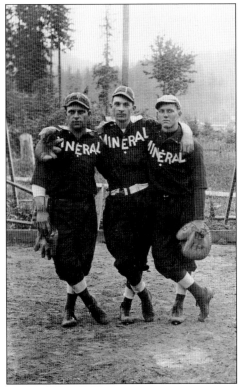

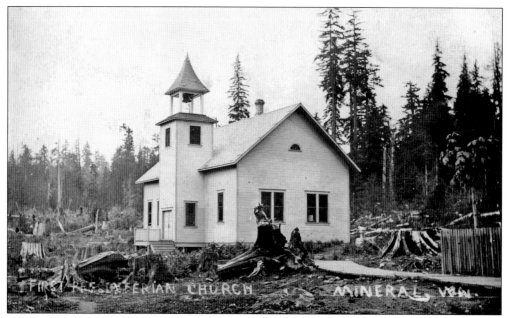

When the railroad arrived, so did the churches. In 1906, two churches were formed in Elbe. The Mineral Presbyterian Church was organized in 1907. The church was built on land donated by the Mineral Lake Lumber Company. The company also donated much of the lumber used in construction. The national denomination provided a $600 construction loan. Members of the congregation did much of the work and were serving the community in 1908. (Courtesy of Jim Hale.)

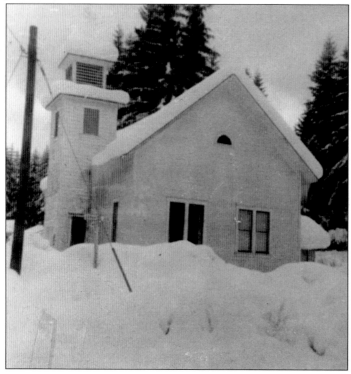

This 1969 image documents the church building, which has not changed significantly, although the town around it went through many changes in the intervening 63 years. This church is still active and celebrated its 100th anniversary of service in 2007. (Courtesy of Jean Shields.)

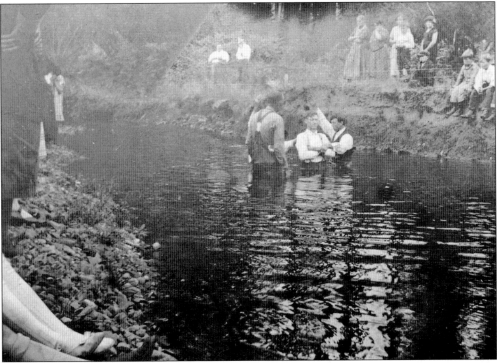

This baptism took place in Round Top Creek. In 1919, J. D. Hale and his cousin Jay Sparkman joined the Old Regular Baptist Church. Eliza Hale and Mallie Sparkman joined the church later. The denomination existed in Kentucky and was imported along with the workers. The group photograph represents the Kentucky expatriates in Mineral. (Courtesy of Jim Hale.)

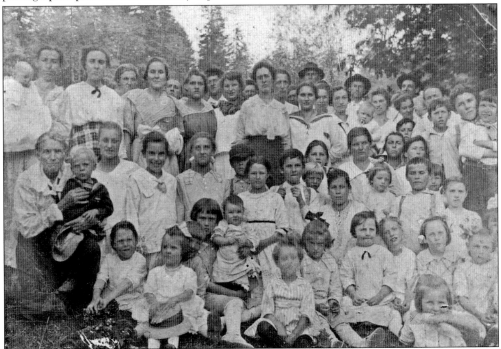

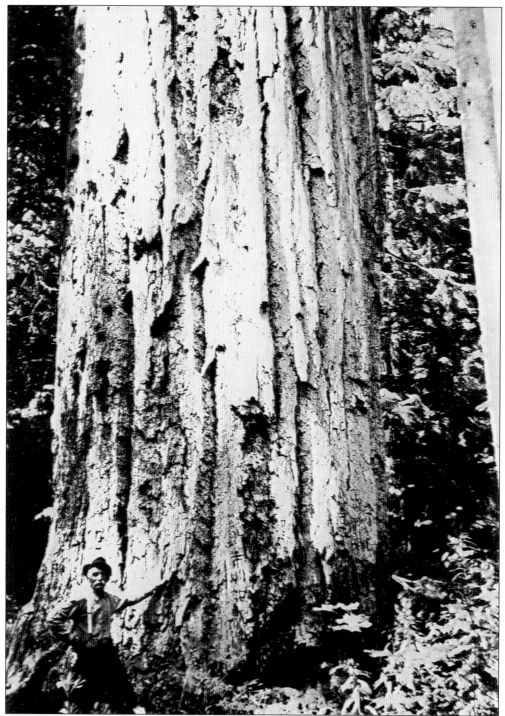

The earliest settlers to the Mineral area discovered a huge Douglas fir, which later became known as the "excursion" or "exhibition" tree. The tree was close to the trail that went from Mineral Creek to Mineral Lake. As the tree was close to the outflow from the lake, and close to the railroad tracks, it soon became a favorite excursion and picnic site. (Courtesy of the Ollie Calvin estate.)

When this tree came down, the top 150 feet shattered and became unusable. Memories and newspaper articles disagree that either the tree was felled or blown over by windstorm, or some combination of the two. About 150 feet of the tree was delivered to the mill to be made into 50,000 board feet of lumber. Cross sections were distributed to Wind River ranger station, a Portland exhibition hall, and Pack Forest, where it can be visited today. The tree was 13 feet across at the bottom and about 1,200 years old. Before it was down, it was a stop for a special excursion train. Over the years, thousands of people climbed on it, carved their initials on it, had their pictures taken with it, and left their calling cards in the holes in it. (Courtesy of the Ollie Calvin estate.)

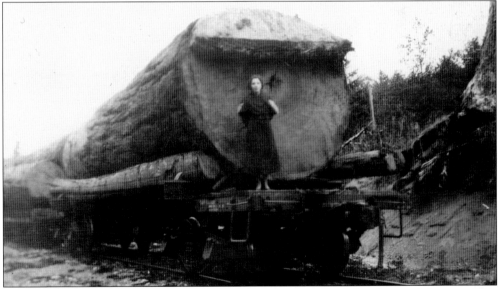

After it was down, the Exhibition Tree was put on a train and exhibited around the area. This picture of Blodwen (Bevan) Truitt was probably taken before the tree left Mineral, but some think this may be another large tree that was harvested by her husband, Louie Truitt. (Courtesy of the Blodwen Truitt estate.)

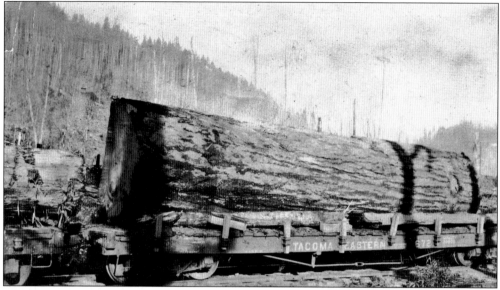

The log was so large that the equipment in the woods was not sufficient to move it in the normal way; it was cut into short sections that the 12-ton crane could safely lift. (Courtesy of the estate of Blodwen Truitt.)

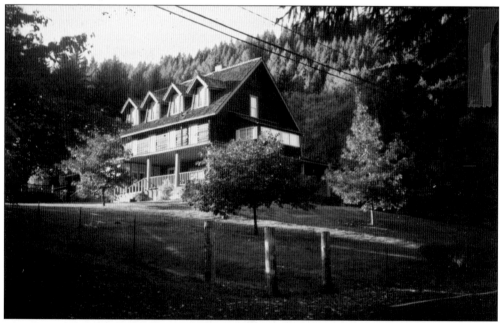

The Mineral Lake Lodge was built in 1906. The 17-room, three-story cedar structure has a veranda on three sides that gives spectacular views of the lake and mountain. Intended to serve the elite citizens of Seattle and Tacoma, it was a short train ride away from the cities. The lodge provided guests with excellent hunting, fishing, and hiking opportunities. Herman and August Ahstrand built it for wealthy radio manufacturer Mr. Gilfellin using old-world Norwegian techniques. Over the years, the lodge had many different individual and corporate owners. It has served as a vacation home, corporate retreat, sanitarium, and currently as a bed-and-breakfast. (MHR, milepost 0.4.) (Photograph by Jean Shields.)

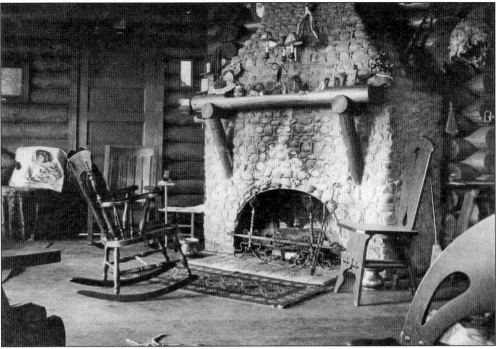

One of the favorite spots in the lodge was the rock fireplace. Guests would gather in the evening to socialize. (Courtesy of Mineral Lake Lodge.)

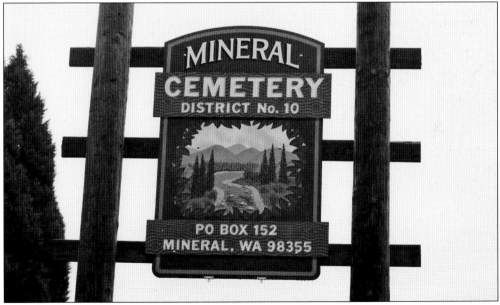

Two of the three Ahlstrand brothers are buried at the Mineral Cemetery. It was incorporated as Bethel Cemetery in 1908 by Levi Engel, N. Thomas, Hans Erickson, John Carlson, Herman Ahlstrand, and August Ahlstrand. At that point, all the timber in the area would have been cut, so the view from the top hill of the cemetery would have included the lake and the town. Graves for many of these signatories and their families are located at the peak of the cemetery's hill, marked by tall trees. (Photograph by Heidi Waterhouse.)

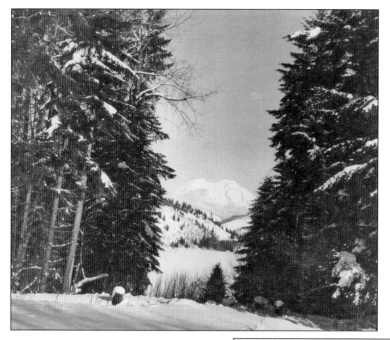

Mount Rainier rises above a solidly frozen Mineral Lake in the winter of 1950. The ice was so thick that locals played games and had ice-skating races on the surface. (Courtesy of Mineral Lake Lodge.)

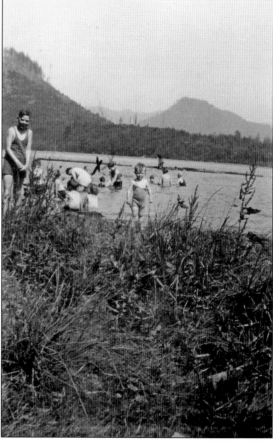

A group of happy youngsters swim in Mineral Lake. After it was used as a logging lake, it became a popular recreational area. William Wilson donated a parcel of lakefront property to Lewis County for use as a swim beach. (Courtesy of the Blodwen Truitt estate.)

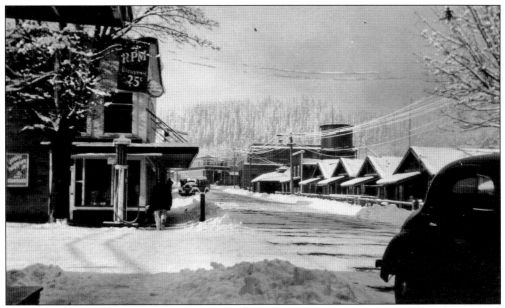

This is Wheeler's General Store as it existed in a winter scene during 1950.

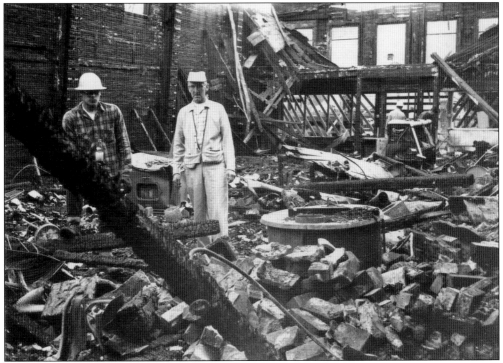

Wheeler's General Store caught fire in 1967. Here Welles Wheeler and volunteer fireman Bill Leybold are standing in the burnt-out building. Two of the town's three general stores were destroyed in the fire: Wheeler's and Pye's. Wheeler, who had inherited the store from his father, wanted to continue his business, so he offered to buy the Hill store. Hill agreed, and Wheeler ran the store until his retirement in 1973. The business was sold to Robert Spencer. In 1975, this store also burned. (Courtesy of Taylor family.)

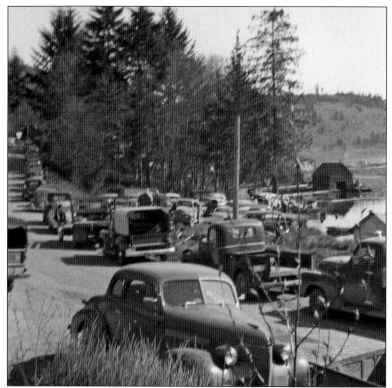

An early-1950s crowd is gathered for the opening day of fishing season at Dunlap's Boats and Cabins (now known as Mineral Lake Resort). This was before the state department of game built the public access to the lake. This is looking north-northeast from Orv and Ada Lilloren's front yard. (MHR, milepost 0.2.) (Courtesy of Dunlap family.)

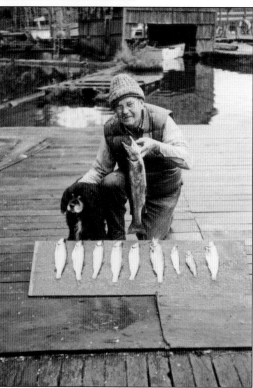

Gordon Dunlap and his dog Rowdy, both of Mineral, displays a day's catch from Mineral Lake. The large fish that he is holding is a brood that was raised in a state hatchery and then released into the lake. (Courtesy of Dunlap family.)

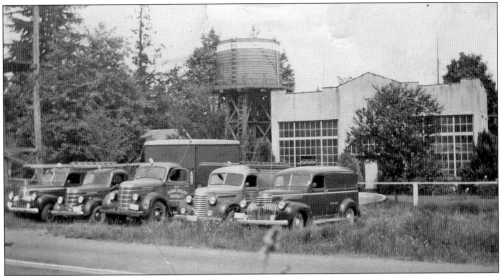

The power plant at the intersection of Mineral Road South and Highway 7 served the communities of Carlson, Ladd, and Mineral. This 1949 photograph shows the trucks used by the Lewis County Public Utility District to serve the area. (Courtesy of Jim Hale.)

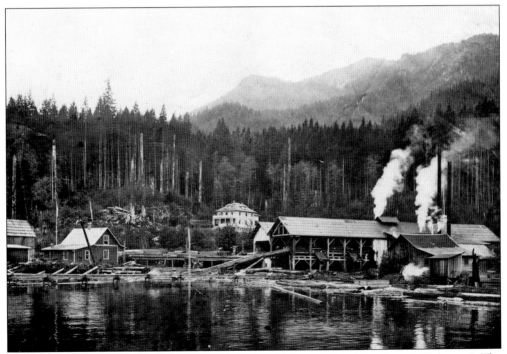

The Carlson mill was located at the intersection of Mineral Road South and Highway 7. The millpond was created by damming Roundtop Creek. Logs were moved to the mill from the hills above by the use of a flume that went under the highway. (Courtesy of the Ollie Calvin estate.)

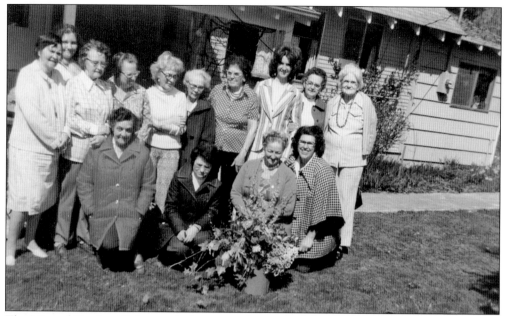

The Mineral Garden Club was a ladies group that worked together to improve their knowledge of gardening, horticulture, and flower arrangement. They undertook projects to improve the appearance of public buildings such as the schools, post offices, fire station, and forestry center. This gathering included, from left to right, (first row) Marty Breckenridge, Dolly Christenson, Ann Moore, and Lois Benton; (second row) Merle McCartney, unidentified, Verna Bevan, Blodwen Truitt, Velma Hale, Ferie Vanderpool, Bella Breckenridge, Linda Smith, Laura Halverson, and Mrs. Clapp from Mossyrock. (Courtesy Lois Benton.)

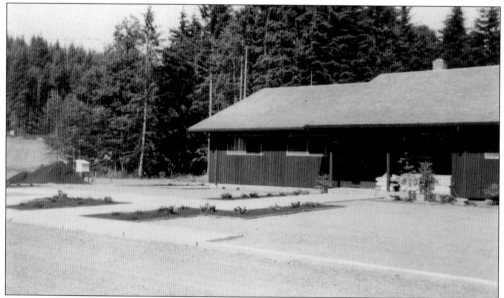

The Mineral Forestry Center started life as a district office for the USDA Forest Service. It was then used as a forest education center by the Morton School District. In recent years, it has been used as a field office for the Washington State Department of Natural Resources. (Courtesy of Lois Benton.)

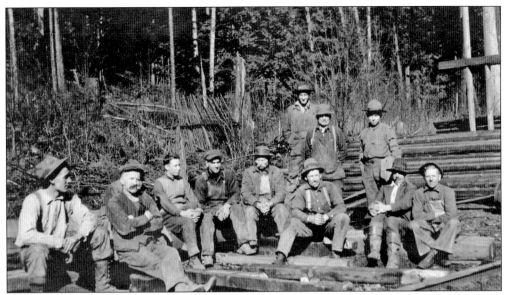

Until 1919, there was active coal mining in Ladd. It supplied coal to the railroad and sold some to outside markets. A fire, which started after a locomotive derailed inside the mine, permanently shut down active mining operations. William Bevin is pictured second from far left. The buildings were modern, with hot and cold running water and heat provided by a central steam boiler, which was coal fired, of course. (Courtesy of the Blodwen Truitt estate.)

Before the mine fire of 1919, in January, a flooding-induced landslide created a natural dam. The dam eventually broke and the resulting freezing water and mud swept through the settlement knocking the buildings off their foundations. Three people were killed. These are the remains of the bunkhouse, which held single men and men with families living elsewhere. (Courtesy of Nancy Wing.)

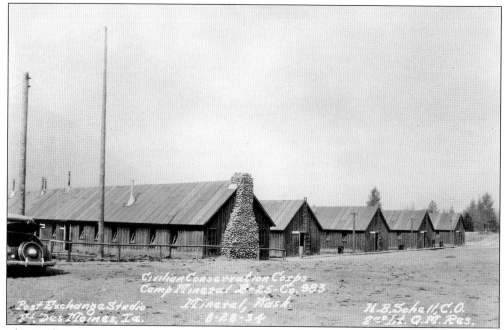

The Civilian Conservation Corps established Camp Mineral early in 1934. The camp was located at the end of the county road in Pleasant Valley. Men between the ages of 18 and 22 years old were enrolled from around the country for a period of six months. They could enroll for a total of two years. They worked 40 hours a week, for which they received $30 a month, with a requirement that $22 to $25 be sent to a family dependent. They also received food, clothing, and medical care. (Courtesy of Jim Hale.)

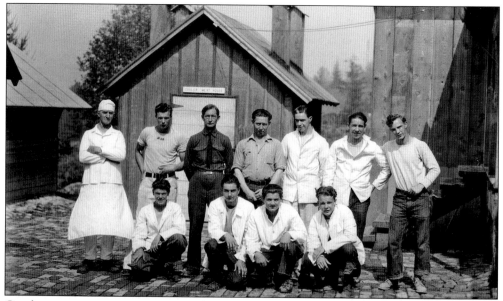

Good nutrition was an important goal for the CCC. The recruits were coming into the corps from families who had been suffering from severe financial distress for months or years. The cooks at Camp Mineral were drawn from the recruits and worked under the supervision of military reservist. (Courtesy of Jim Hale.)

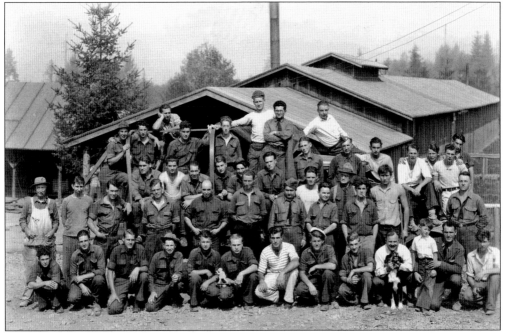

The camp was organized by barrack groups and then subdivided into 20-man work groups. The camp did much to open up the Little Nisqually and Ladd Pass area. They built roads and bridges, planted trees, suppressed forest fires, and in general improved the forest. Since they were mostly farmers or from the cities, the local loggers viewed them with disdain. (Courtesy of Jim Hale.)

The headquarters for the local CCC was at what is now North Fort Lewis, near the museum. The recruits were brought to the camp in trucks and buses. There were other camps at Electron, Pack Forest, near Elbe, and over 1,000 men working in the Mount Rainier National Park at a time. (Courtesy of Jim Hale.)

Pleasant Valley Road winds its way along the south side of the Nisqually River, then turns south along the Little Nisqually River. It is now included in Forest Service Road No. 74. (Courtesy of the Marie Fore estate.)

Eight

BACKWOODS AND HIGH COUNTRY

Springboard logging was hard work, and seems wasteful to our modern sensibilities, but there were sound reasons for the practice. First, axes were used to cut notches in the tree so the loggers could place their springboards. Once the loggers were raised about 4 to 6 feet off the ground, their saws had a clear sweep without interference from undergrowth. The notches and direction of cutting controlled the direction of the fall. The loggers had a clear, safe place to stand while they were felling the tree. All they used to fell trees, even the biggest of them, were axes, hammers, wedges, and two-man saws. The notches can still be seen on stumps along the roads. This collection of pictures portrays a way of life that built many communities here in the northwest. To this day, log trucks continue to roll into local mills, and milled lumber supplies residents with houses, decks, and utility poles.

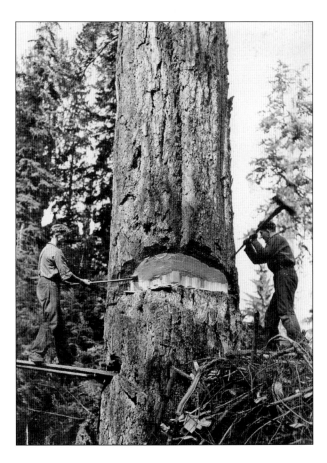

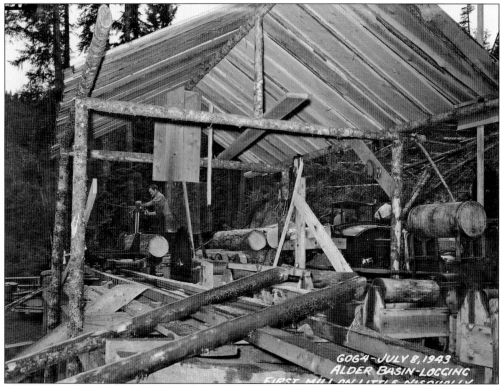

Tie mills were a very important part of the local economy as the nation emerged from the Great Depression. It took approximately 5,000 ties for each mile of rail line. A normal tie was 8 feet long and 8 inches wide, and it needed to be flat on at least two sides. Using small diesel motors, a team of two to four members could make a decent living. (Courtesy of Tacoma Public Utilities.)

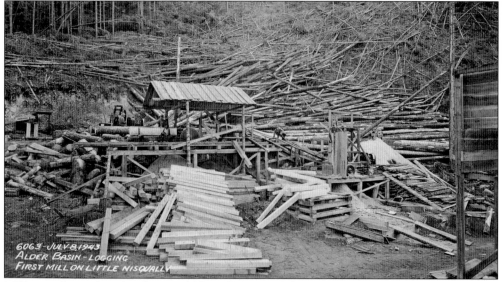

Mills were located so that logs could be rolled downhill and then pulled up to a carriage that moved the log against the saw blade. The unwanted slab fell away to a waste pile. The tie was ejected onto another pile for shipment to market. (Courtesy of Tacoma Public Utilities.)

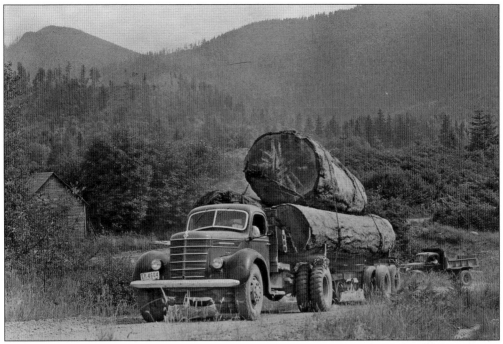

A three-log load comes down the Pleasant Valley Road from the Little Nisqually River. After World War II, more and more operations converted from railroad to truck logging. Trucks were more flexible, and smaller tracts of land were viable for cutting. (Courtesy of Tacoma Public Utilities.)

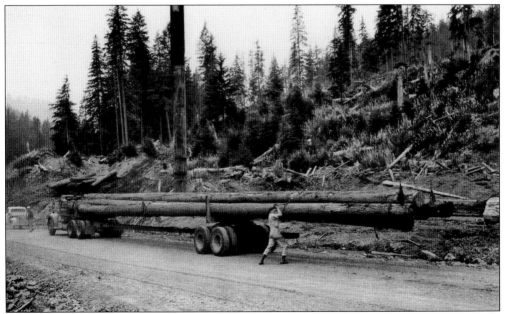

Not all logs were made into lumber. This load of logs, over 100 feet long, will most likely will be treated to prevent rot and then used as pilings or utility poles. This load is coming out from the Mineral Creek Tree Farm, which is over 55,000 acres southeast of the town of Mineral. (Courtesy of Tacoma Public Library.)

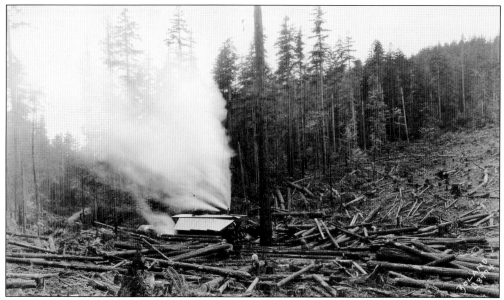

A landing was established after the bushliers had completed their work and the limbs were removed from the tree trunks. A steam-powered winch called a donkey was rigged to a system of cables running through pulleys at the top of a spar pole. A spar pole was a tall tree that had been de-limbed but not yet felled. Using this equipment, logs are drawn to the landing where they are then loaded onto trains or trucks for transportation to the mill. (Courtesy of Marie Fore estate.)

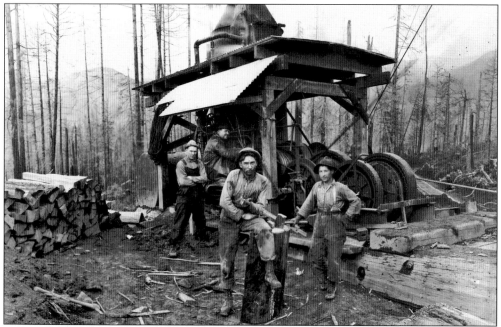

Scenes like this were common in the woods during the reign of steam logging. The crew of the donkey were known as a side. The day's firewood for the boiler can be seen on the left. The skids on which the boiler and wenches rode are seen on the lower right. To move the unit, a cable was run out to a tree or stump in the direction desired, and the donkey pulled itself along. (Courtesy of Jim Hale.)

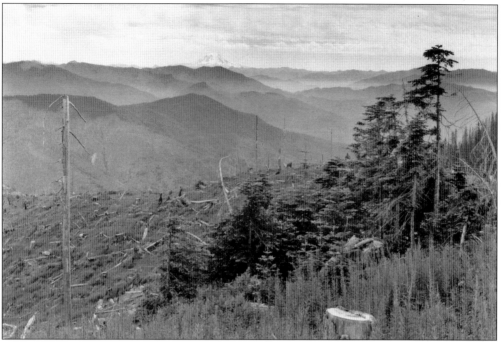

There are snow traces lingering on the mountain framed by replanted trees on land belonging to the Mineral Creek Tree Farm. This picture was taken in July 1962 in the Mineral-Morton area. (Courtesy of Tacoma Public Library.)

Mount Rainier rises distantly over the Mineral Creek Tree Farm. The tree farm is approximately 56,000 acres, covering most of the Mineral Creek drainage area. This area has been clear-cut and replanted. This land belonged to the Murray family and was logged by the St. Regis Company. (Courtesy of Tacoma Public Library.)

On either side of the Nisqually River above Elbe, ridges run east and west up to Mount Rainier. The ridge to the north is accessed by the Copper Creek Road and gives the traveler wonderful views of Mount Rainier and the Puyallup drainage. It has trailheads that lead into the Glacier View Wilderness Area. (Photograph by Loren Lane.)

To the south is the Skate Creek Road that connects the Nisqually Valley to the Cowlitz Valley. A side road leads to the site of the High Rock Lookout. Jim Hale, seen here with his wife, Edie, served as a young ranger when the site was active in the late 1930s. (Courtesy of Jim Hale.)

This crew pauses work on the rail line to watch the sun set on Mount Rainier. This picture shows the three great themes of the Upper Nisqually Valley: the beauty that draws tourists and pleases locals, the resource extraction of hydroelectric power and forestry goods, and the transportation corridor that provides a way to move both goods and people.

BIBLIOGRAPHY

Engle, Pearl, and Jeannette Hlavin. *History of Tacoma Eastern Area.* Vols. 1 and 2. Eatonville, WA: self-published, 1954.

McAbee, Jesse Clark, and Russel H. Holter. *Rails to Paradise: The History of the Tacoma Eastern Railroad (1890–1919).* Rochester, WA: Gorham Publishing, 2005.

Nadeau, Gene Allen. *Highway to Paradise.* Puyallup, WA: Valley Press, 1983.

Ott, John S., and Dick Malloy. *The Tacoma Public Utilities Story: The First 100 Years (1893–1993).* Tacoma, WA: Tacoma Public Utilities, 1993.

Sparkman, LaVonne. *Before It's Gone: Old-Timer Tales.* Sparkman Publishing, 1998.

———. *The Trees Were so Thick There was Nowhere to Look But Up! Early Settlers of Morton and Mineral Washington.* self-published, 1989.

Troy, Vera Ginde, Dorthy Wooldridge Person, and Isabel Rosmond Collins. *Stories of the Pioneers.* The State Association of the Daughters of the Pioneers of Washington. Eatonville, WA: self-published, 1986.

usps.com/postmasterfinder

uppernisquallyvalley.com

vulcan.wr.usgs.gov/Volcanoes/Rainier/Lahars/Historical/description_kautz_creek_1947.html

ABOUT THE ORGANIZATION

The South Pierce County Historical Society was incorporated in 1985 as a nonprofit, charitable organization to preserve and celebrate the people, places, events, and things that, together, comprise the story of south Pierce County. We strive to achieve this aim through donations, research, acquisitions, education, and member participation. The society served as the parent nonprofit to plan and conduct Eatonville's 1909–2009 centennial celebration.

The society currently holds a long-term lease with the Town of Eatonville, Washington, on property at 101 Alder Street East, in Eatonville's historic Mill Town. Here, surrounded by the beautiful foothills of Mount Rainier, the future Stage Stop Museum will take shape. The town's first home—the Van Eaton Cabin—has been preserved as the museum's focal point.

We invite you to join the South Pierce County Historical Society and help us to grow the Stage Stop Museum. As a regular or life member, you will receive e-mail updates and newsletters detailing events and opportunities to bring history to life!

South Pierce County Historical Society
P.O. Box 1966
Eatonville, WA 98328
253-988-0904
senemaat@rainierconnect.com
stagestopmuseum.spaces.live.com

www.arcadiapublishing.com

Discover books about the town where you grew up, the cities where your friends and families live, the town where your parents met, or even that retirement spot you've been dreaming about. Our Web site provides history lovers with exclusive deals, advanced notification about new titles, e-mail alerts of author events, and much more.

MADE IN THE USA

Arcadia Publishing, the leading local history publisher in the United States, is committed to making history accessible and meaningful through publishing books that celebrate and preserve the heritage of America's people and places. Consistent with our mission to preserve history on a local level, this book was printed in South Carolina on American-made paper and manufactured entirely in the United States.

This book carries the accredited Forest Stewardship Council (FSC) label and is printed on 100 percent FSC-certified paper. Products carrying the FSC label are independently certified to assure consumers that they come from forests that are managed to meet the social, economic, and ecological needs of present and future generations.

FSC
Mixed Sources
Product group from well-managed forests and other controlled sources

Cert no. SW-COC-001530
www.fsc.org
© 1996 Forest Stewardship Council

Find Your Place in History.